# HUMANS OF SAN ANTONIO

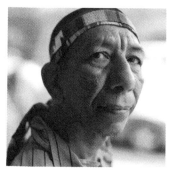 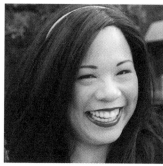 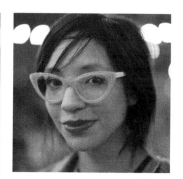

# Humans of San Antonio
## MICHAEL CIRLOS

Maverick Books / Trinity University Press
San Antonio

# Introduction

Today we define San Antonio as a city on the rise. New housing on the River Walk and along Broadway has made urban living possible. The revitalization of city parks and even the changing skyline are indicators of a brighter downtown.

When I was a teenager, in the early 2000s, I would have loved the interconnect-edness of the community, the public art, and even the street food, but San Antonio was a different city. As my dear friend Valerie said back then, "San Antonio is a place to exist, not a place to truly live."

I knew that if I wanted to experience more art and urbanism, I had to leave. In 2005 I moved to Hua Hin, Thailand, to study international relations and psychology at Webster University. Two years later I earned a scholarship to continue my studies at Webster University Leiden, in the Netherlands. My flat was about a mile from the university, and during my morning walks to class I occasionally took photos on Haarlemmerstraat. Eventually, in 2009, I transferred to the University of Texas at San Antonio.

One day, in the summer of 2012, I met a friend for a drink at the Flying Saucer. She had grown tired of hearing me talk about the absence of a larger art community and San Antonio's poor after-hours mass transit. She pulled up the Humans of New York webpage on her phone and showed it to me. That's when it began to dawn on me that I could raise awareness of my own city's urban landscape

and celebrate its diversity and inclusion. I could do San Antonio's version of the Humans project. I'd document the authenticity of our community and show the rest of San Antonio that downtown was the place to be.

That October I bought my first D-SLR camera and began to photograph and interview people downtown—sometimes during my lunch hour but mostly after work or on weekends. At first I felt awkward asking people personal questions about their lives, and I wasn't sure how Humans of San Antonio would turn out. Street photography didn't seem to be common in the city. Sometimes I felt like giving up. But the more I photographed, the fewer obstacles I encountered and the more comfortable I became with my camera.

The images I took for Humans of San Antonio in the first week have left the biggest impression on me even now, almost five years later—from the homeless man at the corner of South Saint Mary's and Commerce Streets to a woman eating a large bowl of spaghetti and meat sauce outside Pearl Brewery, to the gentleman with the black leather top hat I met in front of city hall.

I struggled a bit and asked terrible follow-up questions, but the process and the prospect of improving were exciting. Part of my plan was to shoot everything with a shallow depth of field to blur out the background. I wanted the subject's face in plain view. The interview and story were brief so that the main points translated quickly and clearly to the online world, where they were posted on the Humans of San Antonio blog. After I introduced myself I always asked, What is one memory you never want to forget?

I've photographed and interviewed over a thousand people for Humans of San Antonio. Though this book features just a small selection of them, it serves as a photographic testament to what makes downtown San Antonio special. Our vibrant city is evolving at a pace that is sometimes not visible to the eye. I always encourage people to explore the city and take a break from the familiar. Ride a bicycle through downtown. Have lunch at a city park or take a ride on a river barge. If I've learned anything at all from this project, it's that it's all about who you're with. The only thing that separates you from the people in my images is a matter of inches, just physical space. These are the people who walk past you, live beside you, and laugh alongside you.

The Humans of San Antonio project is not a "they" or a "he" or a "she." It represents the entire community coming together, celebrating our differences, and wanting not just a place to exist but a place to truly live.

"One day when I was twenty-three, my father fell out of the back of the pickup truck where he was sitting, hitting his head on the concrete. He suffered a brain hemorrhage and died later that day. He was fifty-four."

*What do you remember most about your father?*

"My father taught me how to say, 'Sí, señora. No, señora. Sí, señor. No, señor. Con respecto.' My father was a great man."

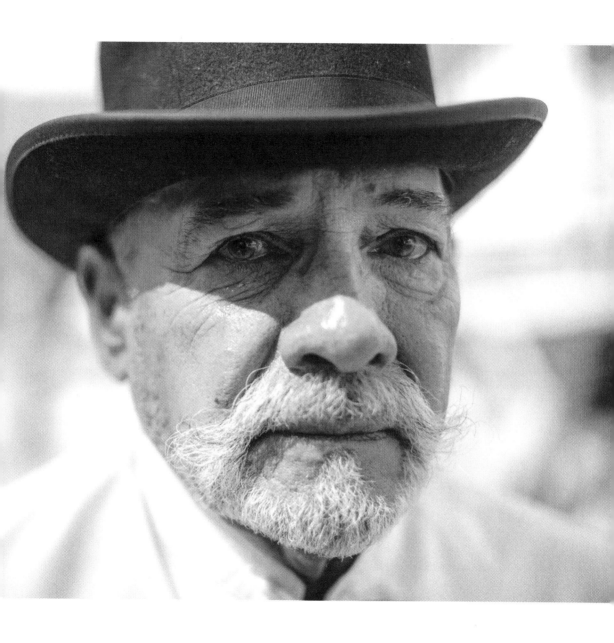

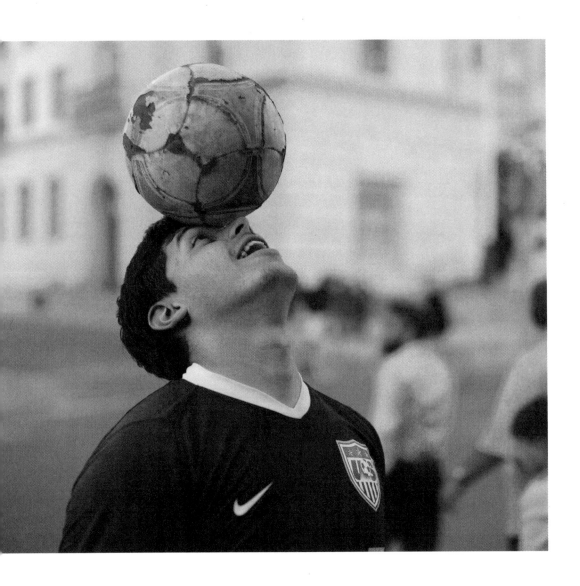

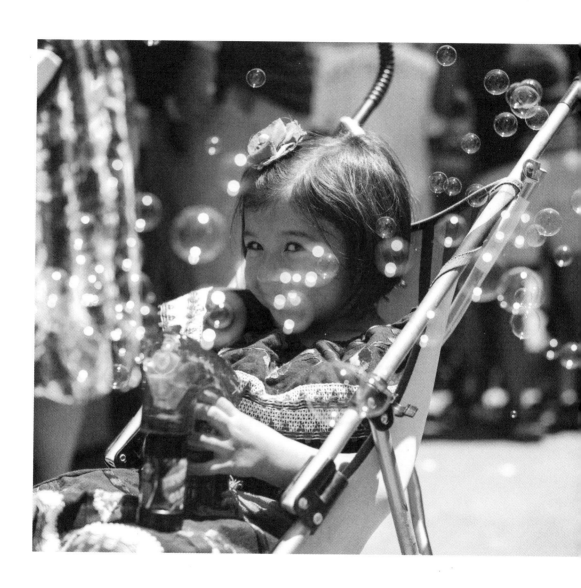

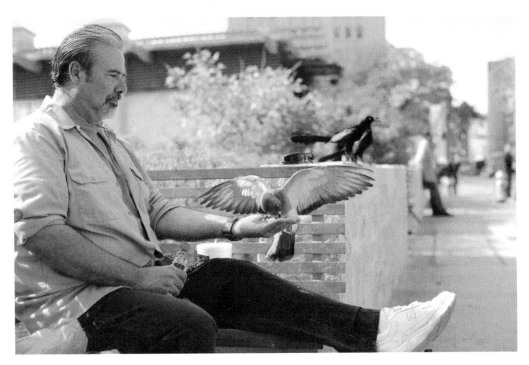

"I've been feeding the birds for about a week now, and this is the only one that will eat from my hand."

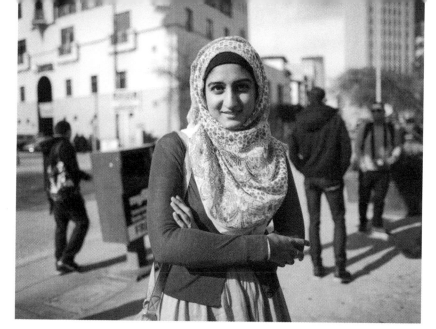

"Our lives are lit by the sun. Whatever the sun is illuminating we are to meet with love and peace."

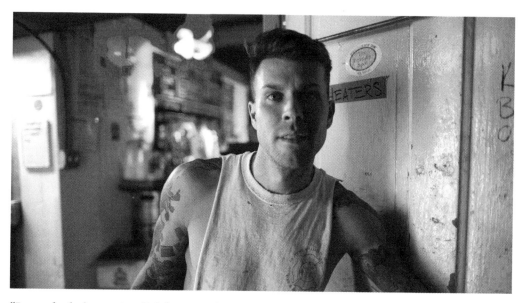

"I saved a baby squirrel's life yesterday."

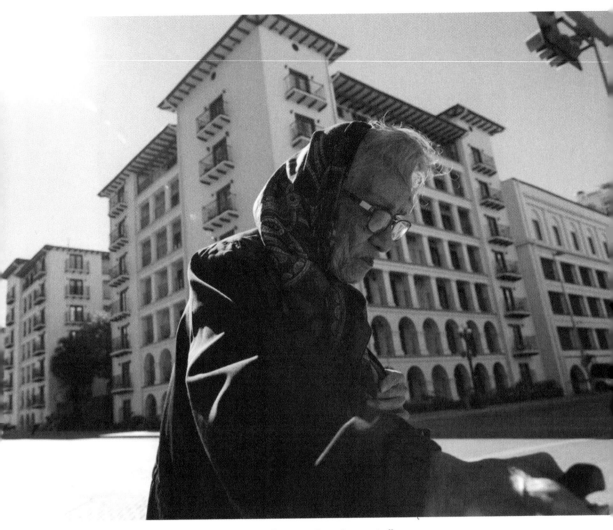

"I spent six years in Philly and ninety-four in San Antonio."

*What are you most grateful for?*

"God. Now will you help me across the street?"

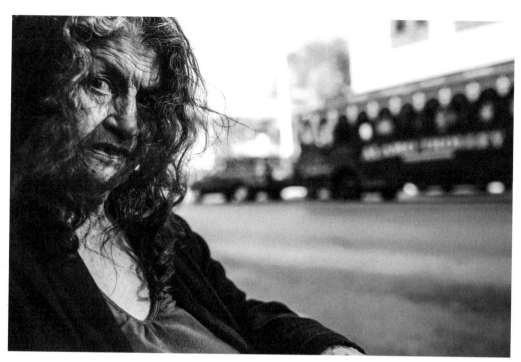

"I don't have a story."

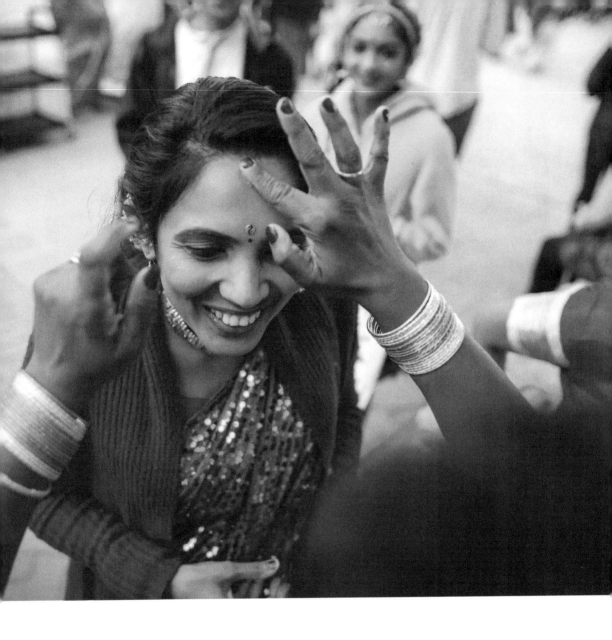

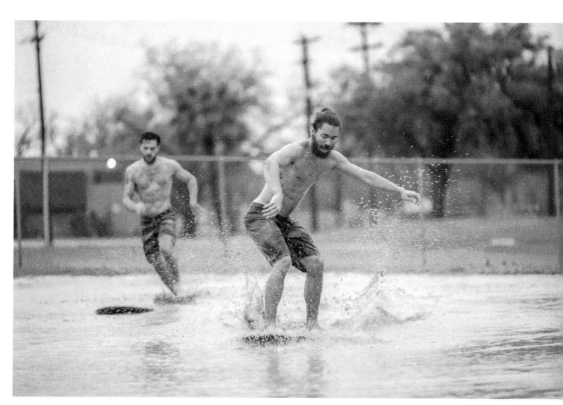

"I don't mind the rain."

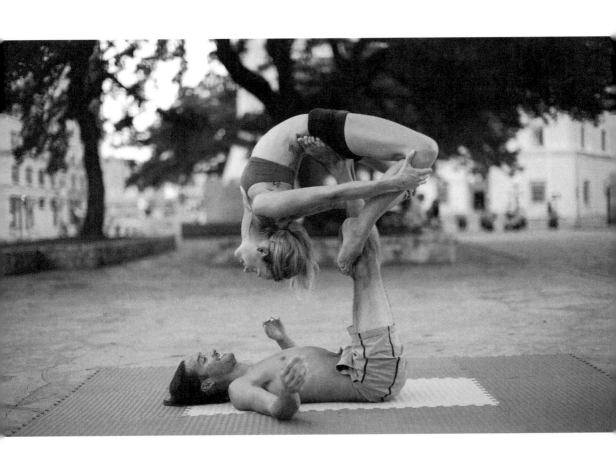

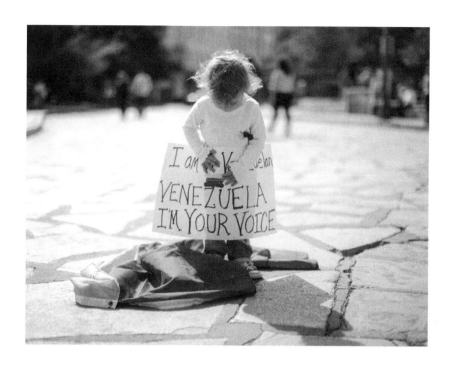

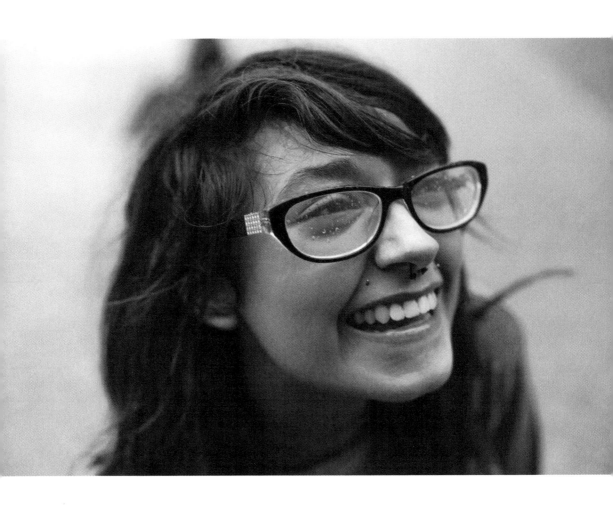

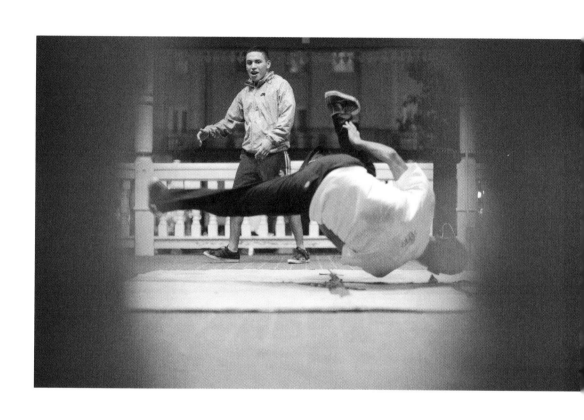

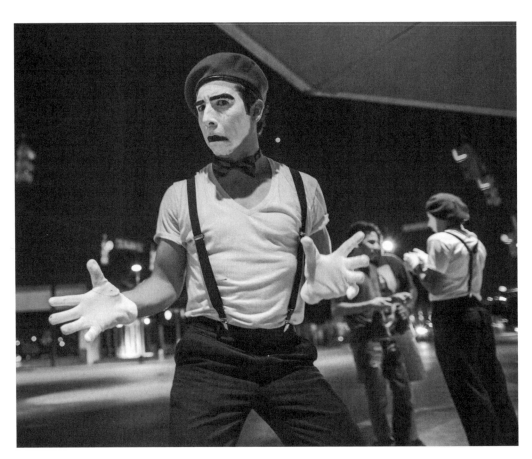

"___"

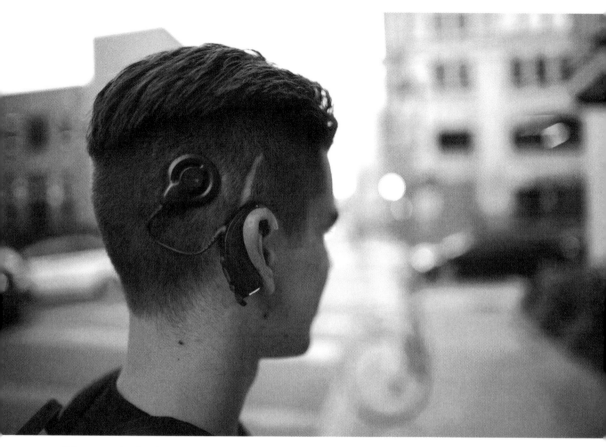

"I'm mostly deaf. Every now and then I lose my hearing for a couple of days. All I can do is take a step back and watch. The silent world is just as noisy. People express how they feel all the time, and it doesn't really matter if you can hear them because you can use other senses."

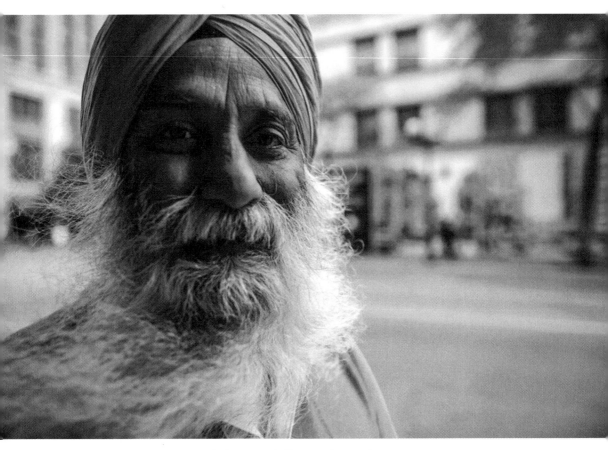

"Let us not accept every single human difference but rather build tolerance and understanding of those differences independent of our human ego."

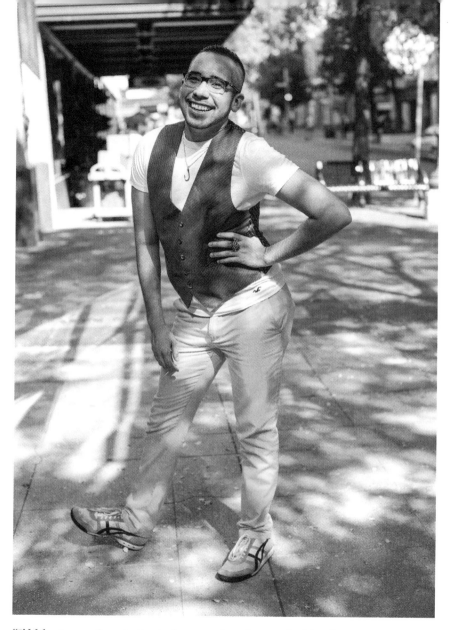

"I'd like to see San Antonio become less homophobic. At a gas station the other day someone yelled a slur at me. Some people need to know that's impolite."

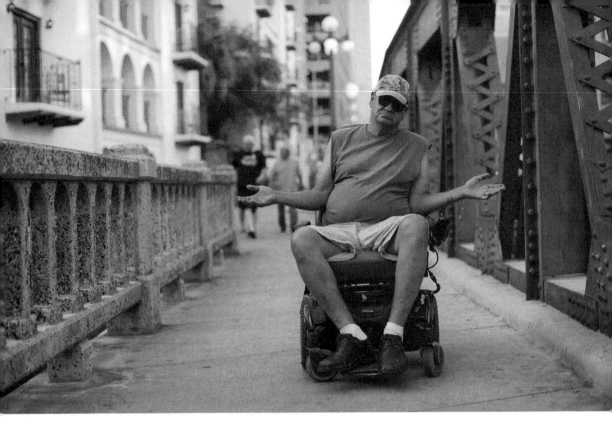

"Thousands of veterans are homeless and disabled in Texas. Chemicals might have destroyed my ability to walk, but it didn't destroy my brain, you [expletive]."

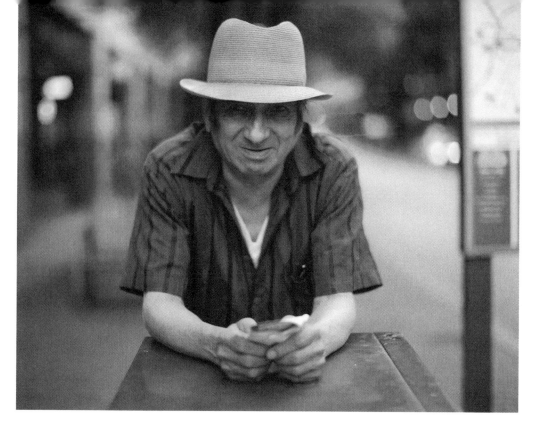

"I joined the army around the same time my brother did.
When I found out he was in Vietnam fighting in an area
that was severely bombed, I thought I'd never see him again.
One day my convoy received orders to go to the same area.
I was so nervous thinking that I wouldn't see my brother.
Fortunately, by the grace of God, he was alive. At first I didn't
recognize him because he was covered in dirt, and he didn't
recognize me because he just couldn't believe I was there.
After giving him a big hug, I looked him in the eyes and said,
'I love you, my brother. I am so happy to see you again.' "

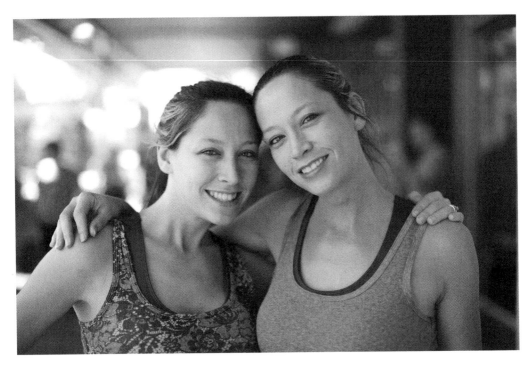

"We both made staff sergeants on our birthday."

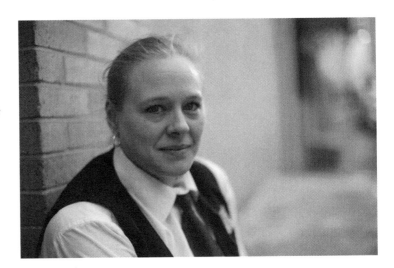

"I knew on my wedding day that the man I was marrying wasn't right for me, but I married him anyway."

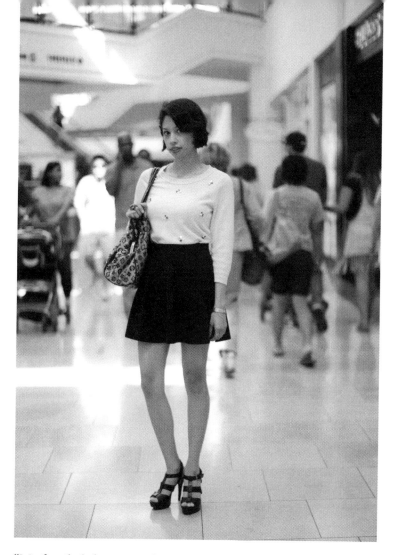

"My family left Mexico for the United States when I was one to give me a better life. My parents taught me to always try my best and to think of obstacles as stepping stones to success."

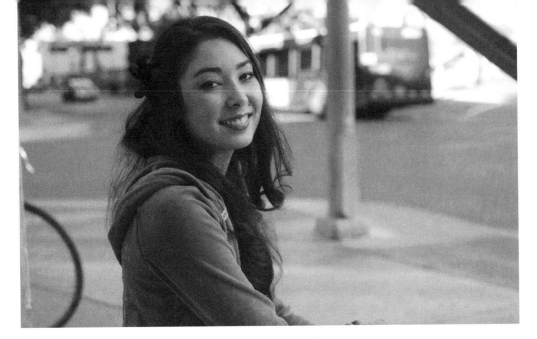

"I was on the dance team in high school, and one day my mom and I got into a huge fight a few hours before my big performance. I didn't think she was going to watch me perform. That night while I was dancing, I saw her there in the stands."

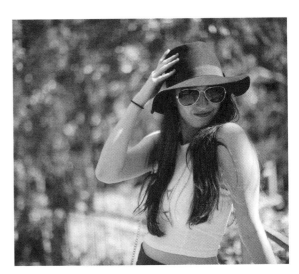

"Managing my emotions after finding out my mother had brain cancer was the hardest thing I've ever had to deal with."

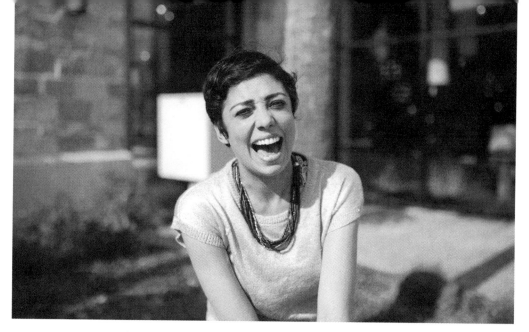

"When I found out I was pregnant, I was screaming and crying, but everyone I called didn't believe me because it was April Fools' Day."

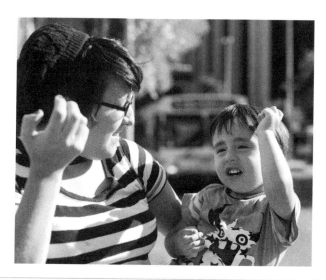

"His favorite thing to do is to play air guitar and sing along to 'Bohemian Rhapsody.' "

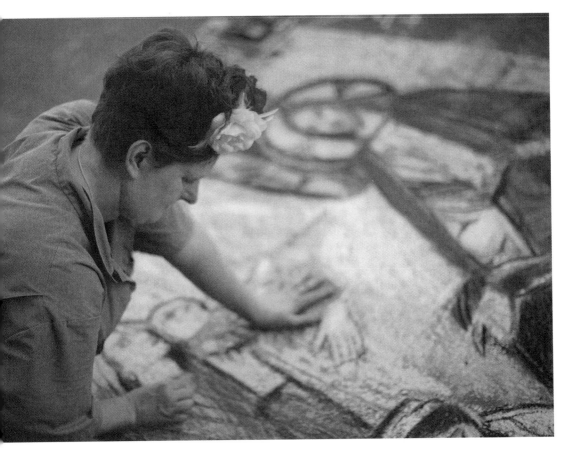

"If you can't be happy alone, you can't be happy with someone else."

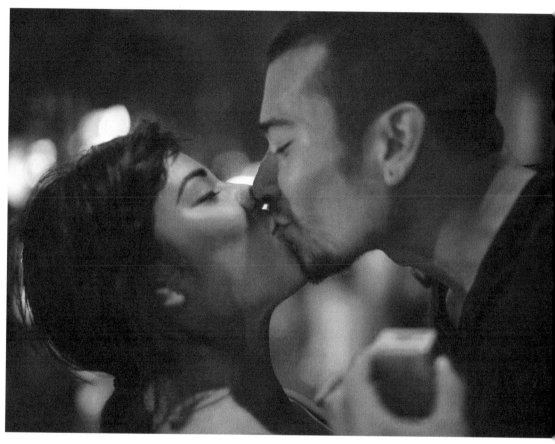

"The best part about my girl's kiss is that it's just as organic as the first."

"Most people don't know the San Antonio River is a sacred river that provides spiritual healing. It belongs to the native peoples. I'd like to pray on the River Walk, but I'm afraid I would get arrested."

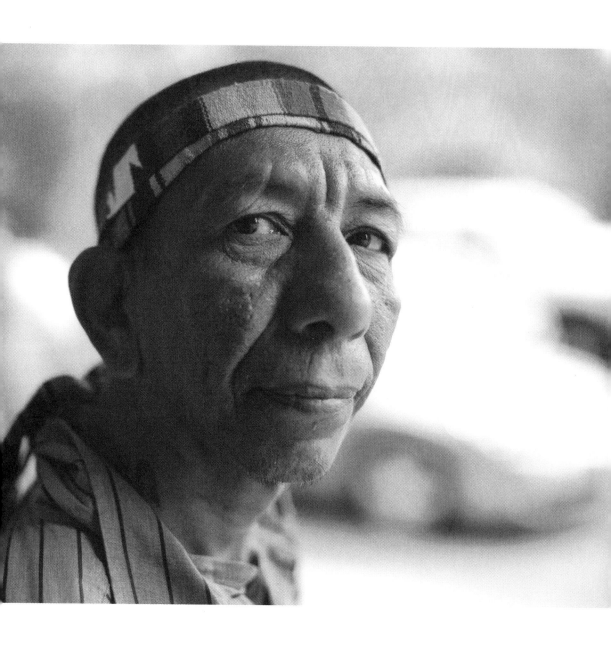

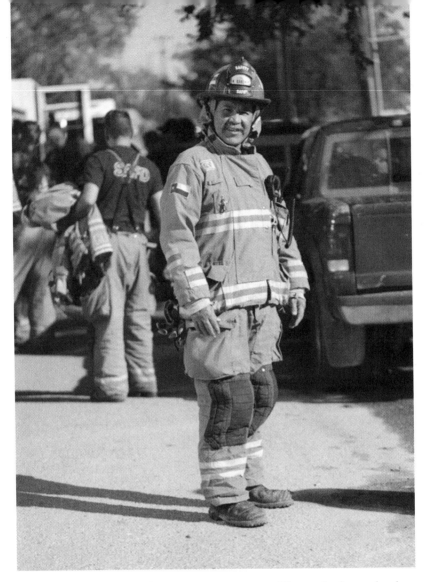

"I've been a firefighter for twenty-nine years. Please don't run back into a burning building for material items. I've seen that happen too many times."

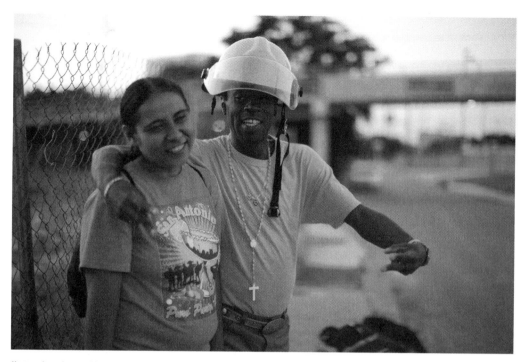

"He thinks yellow brings him good luck. He won't wear another color."

"It makes me angry when people post stupid comments on your blog."

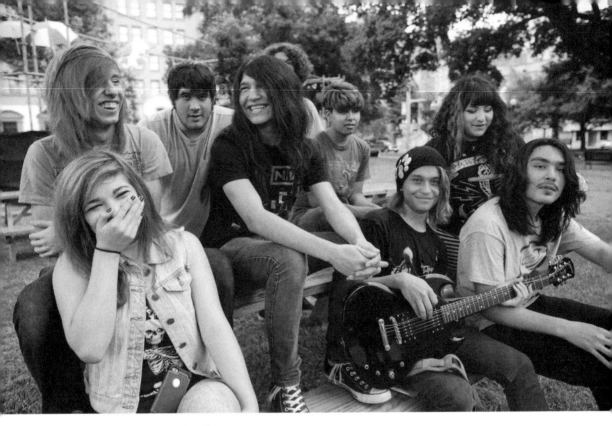

"We perform for the ladies."

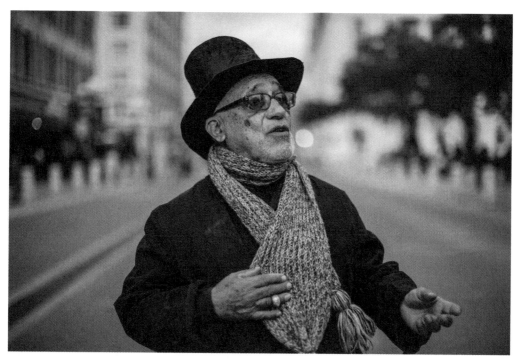

"The Lord wants mankind to get along, so keep others in mind."

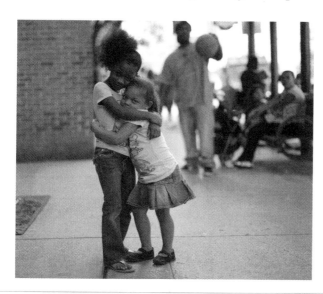

"We're best friends too."

"I like to spend my Sundays with family."

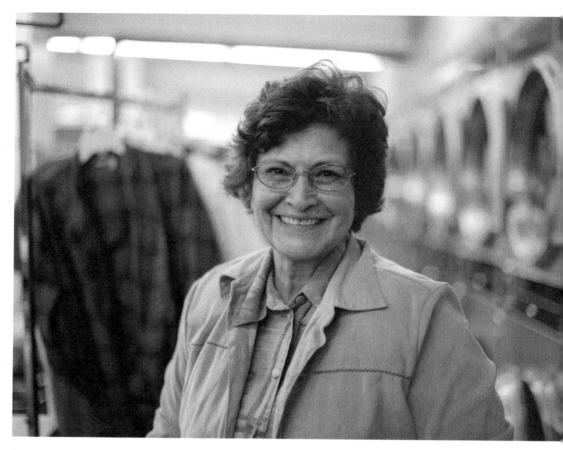

"For sixteen years I worked as a nanny for a family in San Francisco that I cared for very much. The children grew older, and my services were no longer needed. I miss doing what I've always enjoyed—taking care of others."

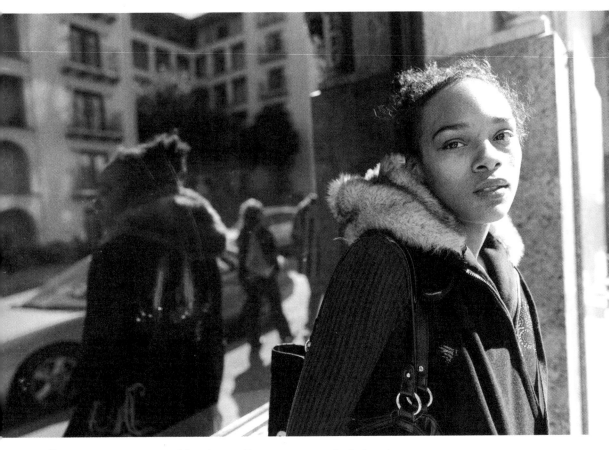

"Being twenty-one and having to live at a women's shelter is my biggest struggle. I'm not going to share excuses with you. I'm just going to say I'll make it out of this situation."

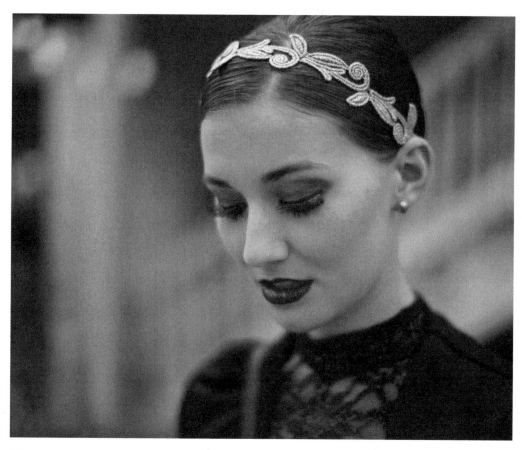

"I'm about to visit my daughter who I haven't seen in two years. I have no idea what I'm going to say."

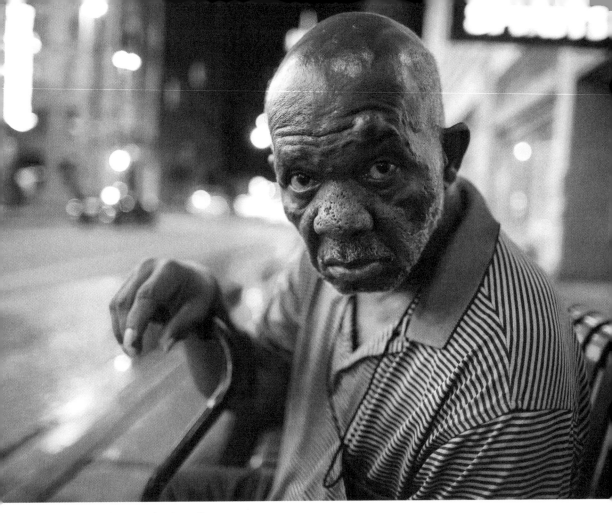

"The Lord knows I'm here."

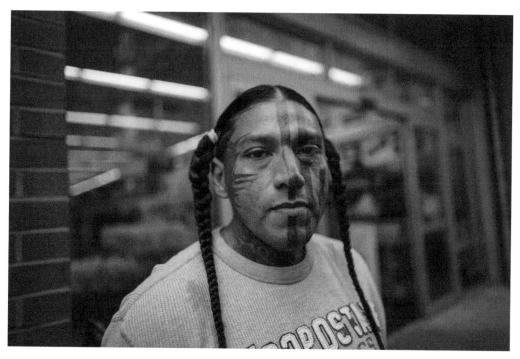

"If you don't have a strong family or support system as a kid you lose sight of what's right. You take a look at your community and see other people in the same struggle. You get older, and things don't get better. You stop caring, and then you become friends with people who look like they're doing better. You need to make money, and then you realize after prison how contagious violence really is."

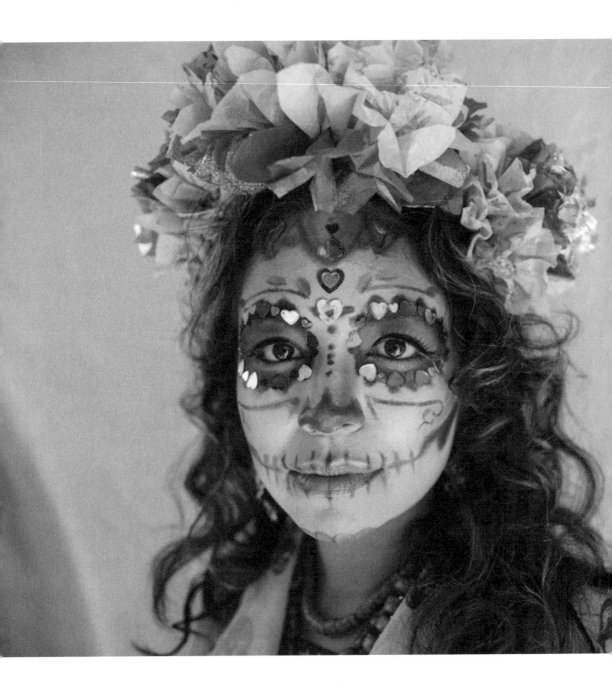

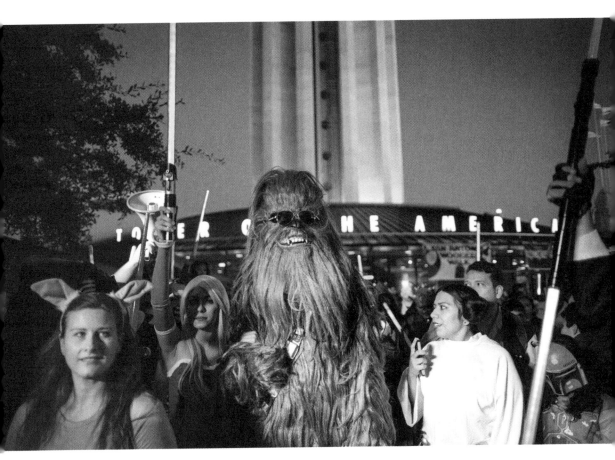

"Grrrwaaaaaarggggh."

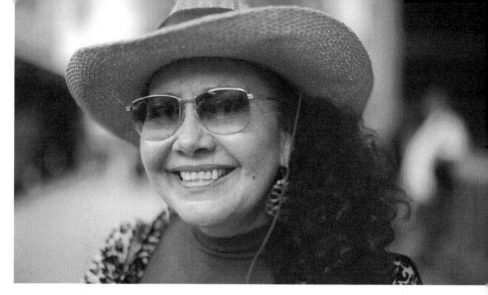

"Women have three ages. The first is, of course, our physical age, which is the one I'm not going to tell you, so don't even ask. The second is our real age, the age we present most of the time. Our third age is the most important one. If you can familiarize yourself with your emotional age, you will be happy-happy!"

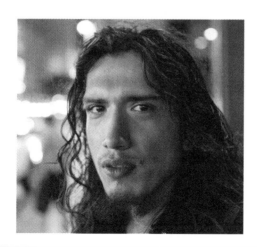

"When I was a foster kid, they brought me to my new grandparents and I rebelled. They wanted me to do chores and follow rules. I didn't know how to live successfully in an environment like that, so I just left."

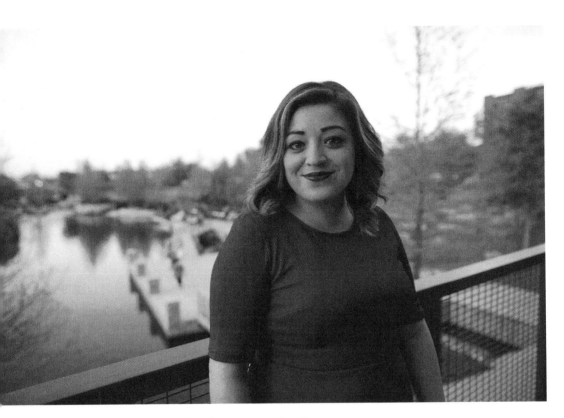

"Most of the residential development in the downtown area is too expensive for young professionals. Without them, San Antonio will stay a quiet sleepy little city."

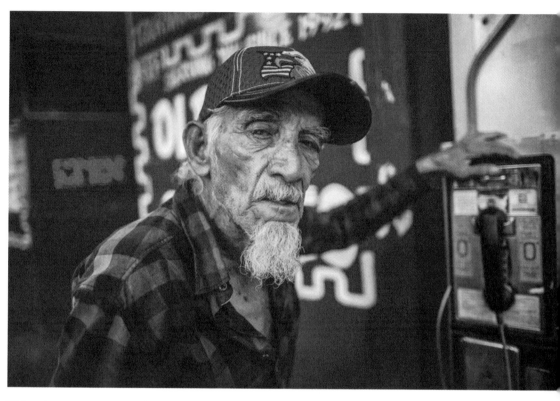

"They're starting to push the people out of their neighborhoods."

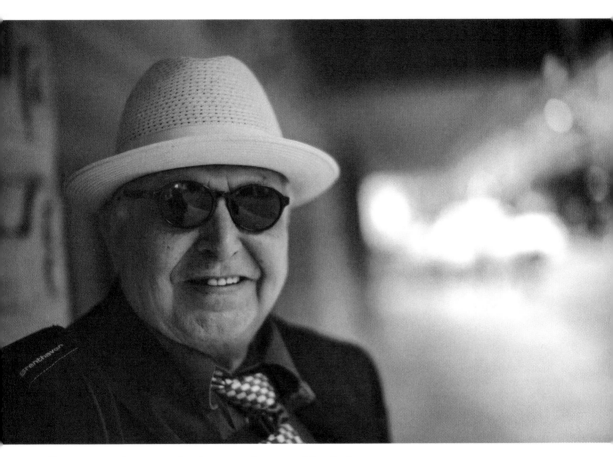

"My Native American heritage can be traced back about ten thousand years. We've become a city where economic development occurred away from our culture and heritage."

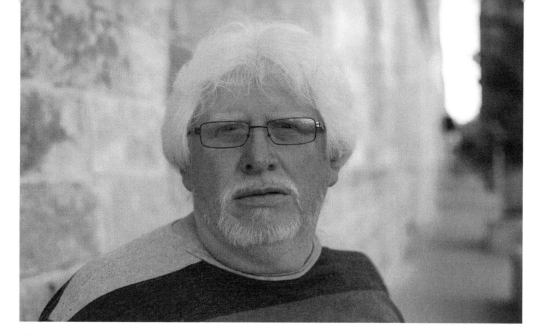

"I've learned that you can't take things too seriously because that takes all the fun out of it. The universe is infinite and flexible, so it makes sense that you have to be flexible too."

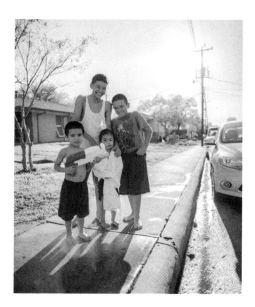

"We just pulled a prank on our mom!"

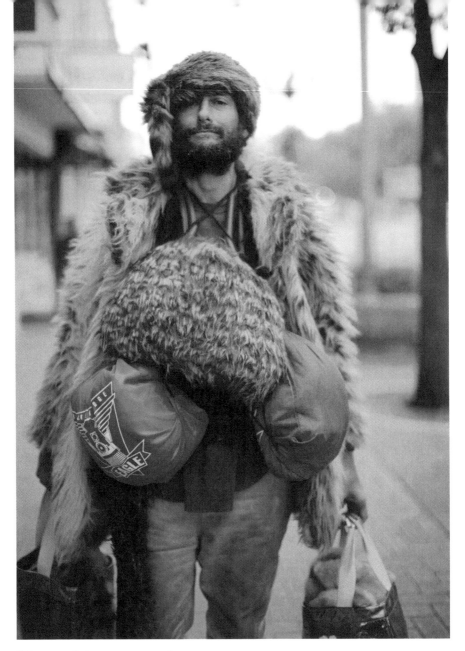

"Your trash is my treasure."

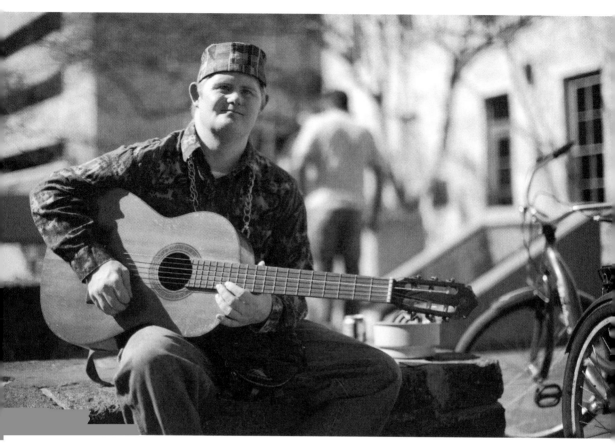

"My heart plays the guitar."

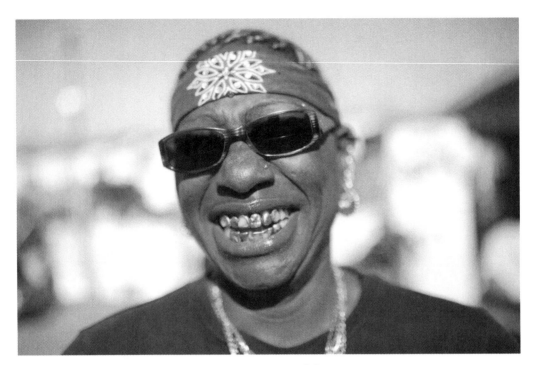

"Sometimes I feel like people judge me because of the way I look. I just want to reach out and tell them you can't judge people from the outside."

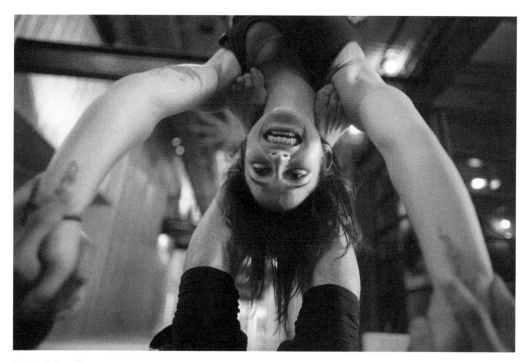

"We did it!"

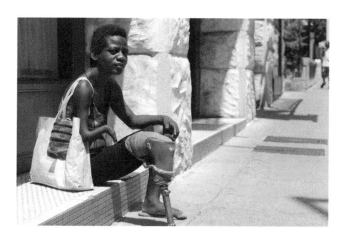

"Once you get over your insecurities, nothing can really bother you."

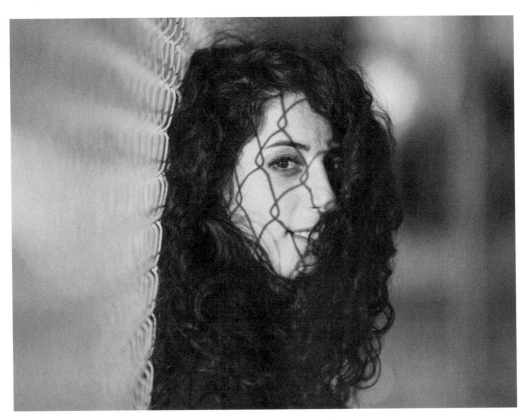

"The happiest moment in my life was the day I stepped on grounds outside of Iranian soil."

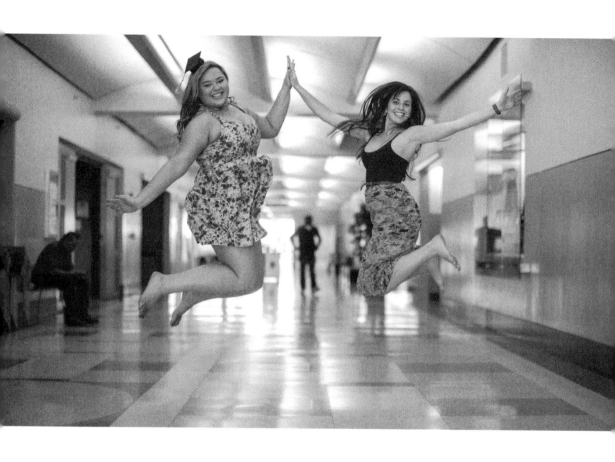

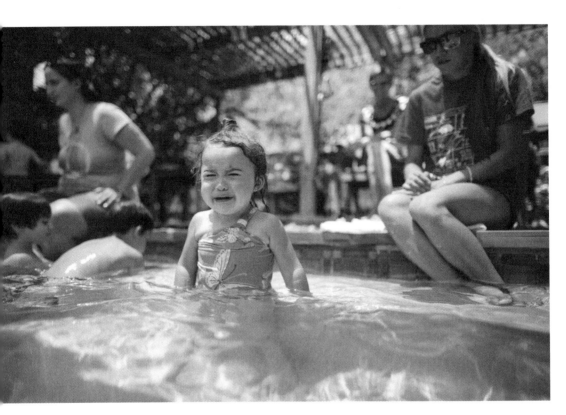

"I don't like swimming."

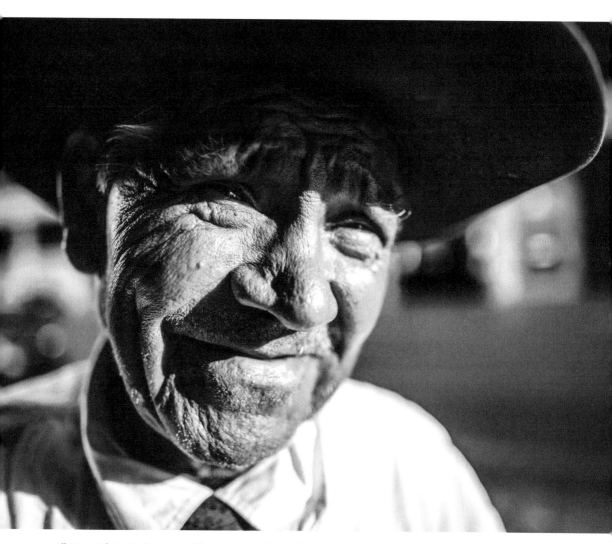

"My wife is in heaven. She passed about five years ago, but I still think about her every day. That's why I don't have a girlfriend."

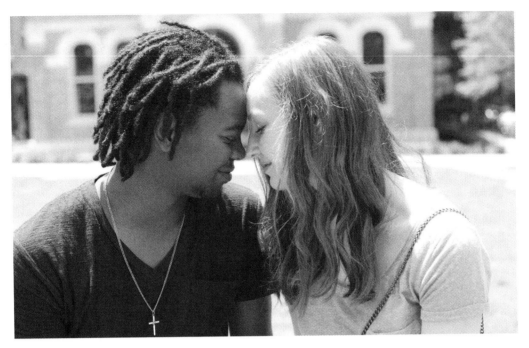

"He's an atheist and I'm a Christian. Despite our differences, we share a common morality, and that's what matters most."

"If there's a time when you know you have to break up, be patient and understanding. I was away from the girl I loved for four years before a phone call got us back together."

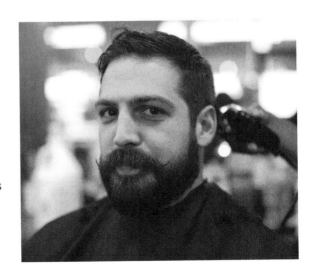

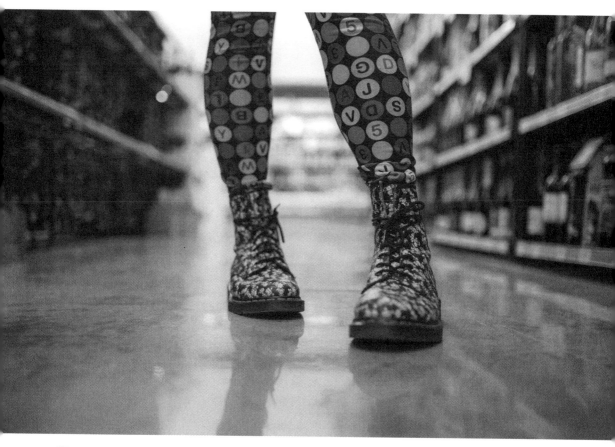

"Sometimes you have to take a leap of faith. I saw him at a Christmas party and thought he was cute. He started Facebook stalking me, and then I started Facebook stalking him. I found out later that he was going to a show, so I made sure to be there. And that's how I met my husband."

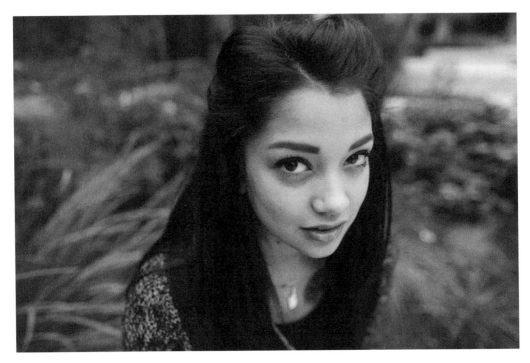

"What's really important is trying to figure out how to have stability in my life. I just want to be content. It's why I focus on working."

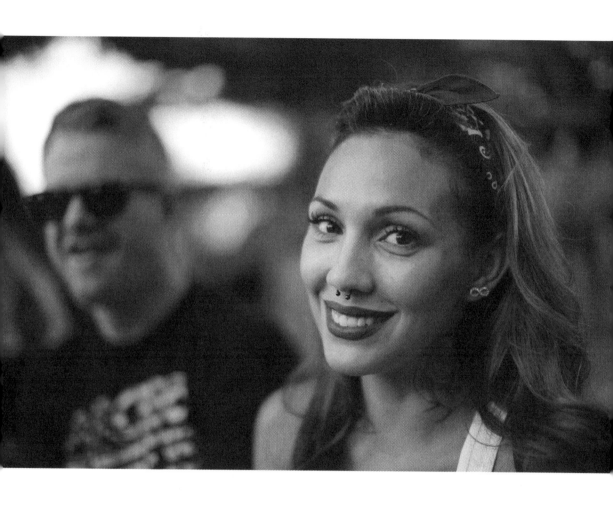

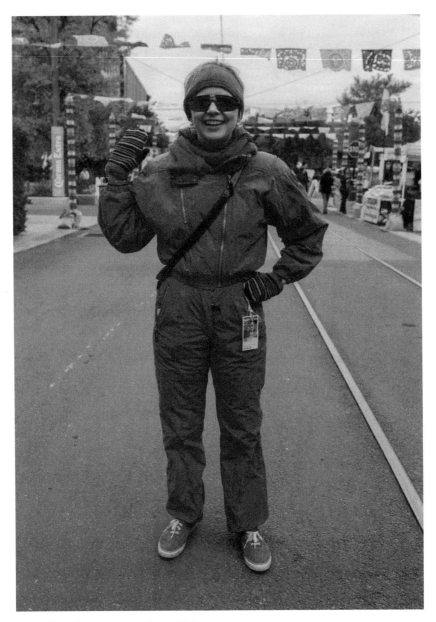

"I'm freezing my tamales off!"

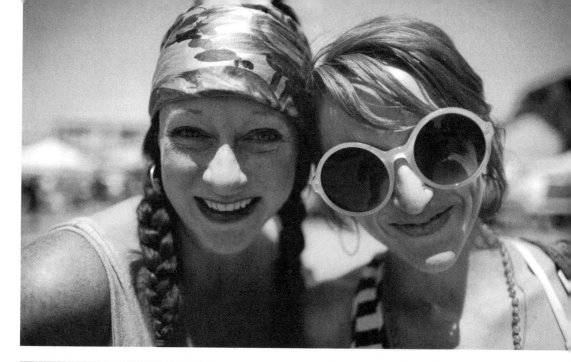

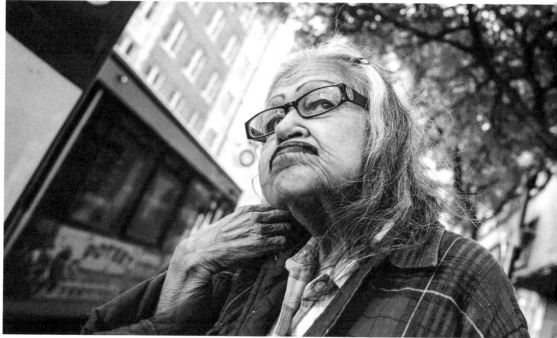

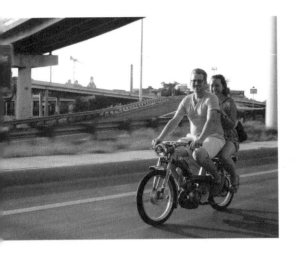

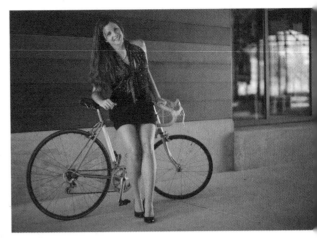

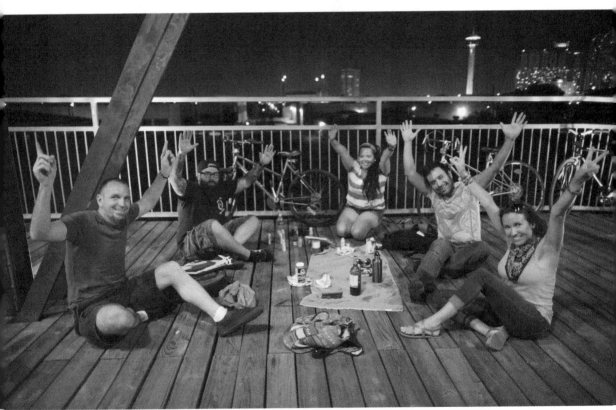

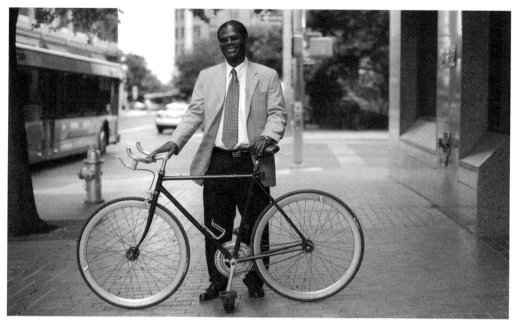

"I catch three buses to get to work. Then I walk a mile or so. I've been praying for a bicycle, and on my way to church a young man came up to me and asked if I'd like to buy this bike."

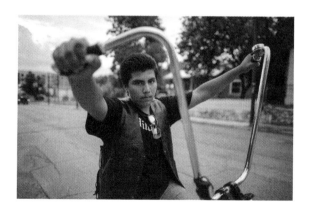

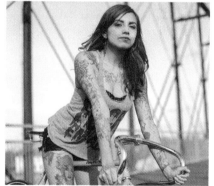

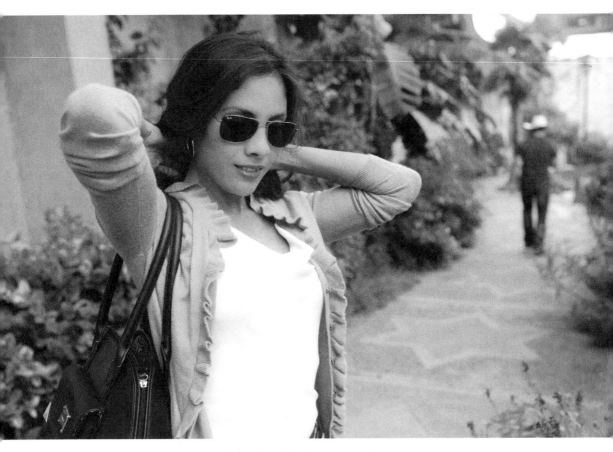

"When we played with the neighborhood kids, my brothers always included me. One day my brother was teaching me karate moves. As I went to kick him, he grabbed my foot and flipped me in the air. I landed hard on my back. My mother ran to my rescue and gave me a soda. 'Para qué se me suba la azúcar,' she said."

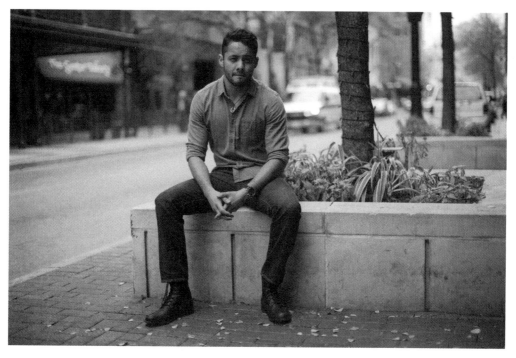

"I started working in the United States when I was thirteen. I worked all week as a dishwasher and had one day off. I'm very responsible now, and I'm trying to pass on the knowledge I've learned from hard work to my siblings. My father isn't with us anymore, so I need to be the best role model I can."

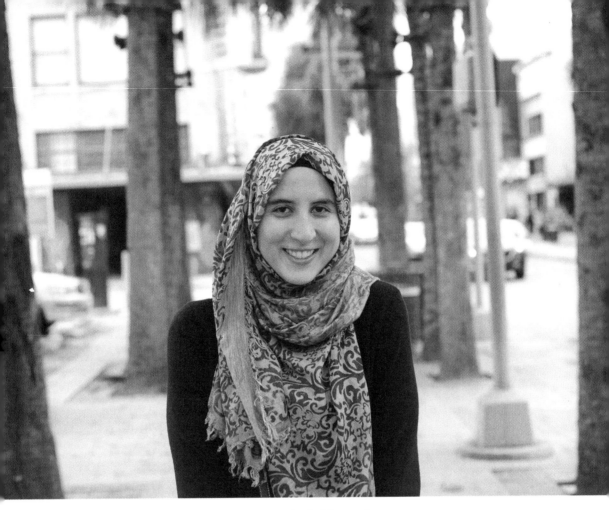

"I memorized the entire Koran in two and a half months
while fasting and going to medical school."

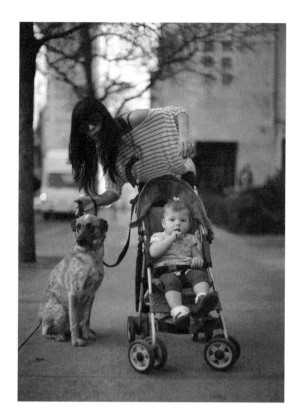

"When I was five my mom bought me a flute. In the arts building we passed a dance class. I looked at my mom and said, 'I don't want to play the flute. I want to dance.' She said, 'Let's try music, and in a week or so if you still want to dance, I promise you will.' I will always love her for allowing me to be me."

"I picked her up from her first day of pre-K. She was so excited to see me that she ran up and handed me a drawing she made in class. I teared up a little bit."

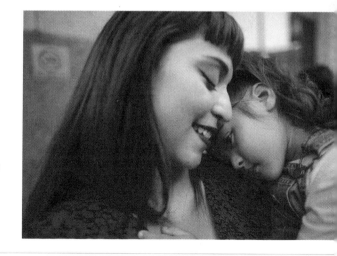

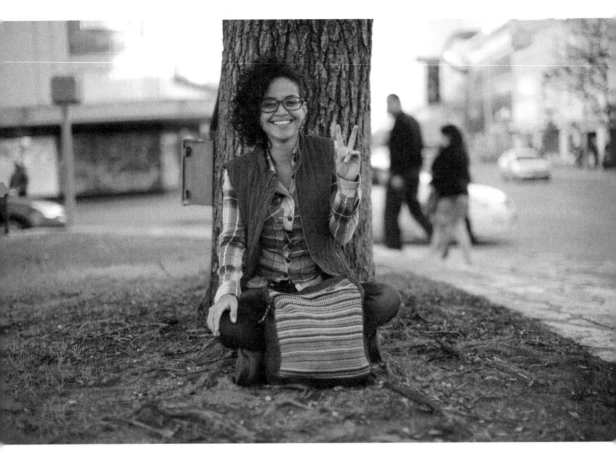

"I'm from Costa Rica, and people there don't appreciate signs
of affection by people of the same sex. I became a lesbian
activist and am traveling around the world educating people.
I rallied thousands of Costa Ricans to come out to the streets
to demonstrate their expressions of love in front of everyone,
and I almost got arrested for doing it!"

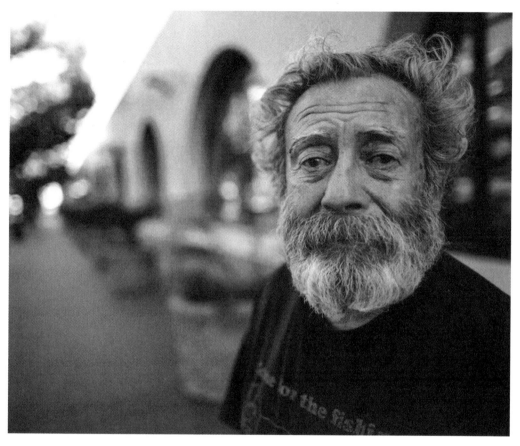

"Don't give up on the people you love."

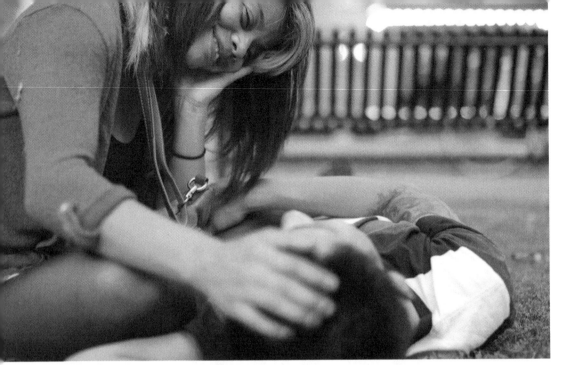

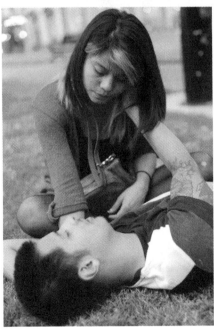

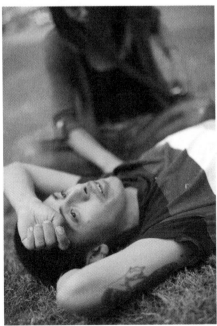

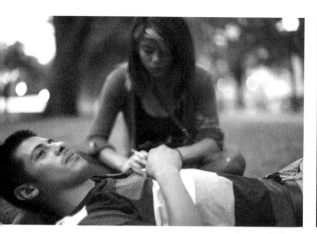

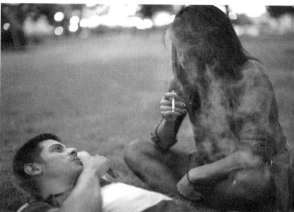

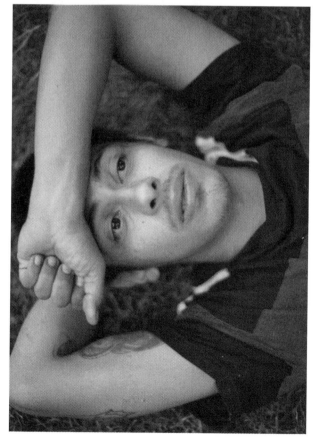

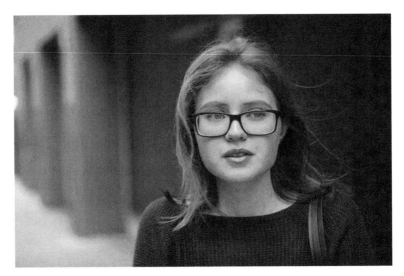

"I wonder what it's like to fall in love. Like, how do you know?"

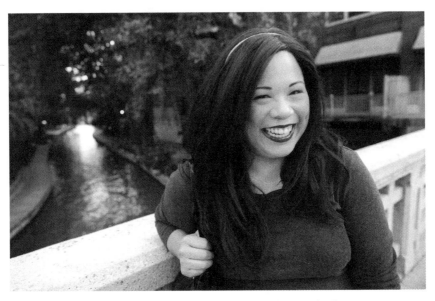

"My idea of love has evolved over the years. Ultimately, love is having the courage to stand alone."

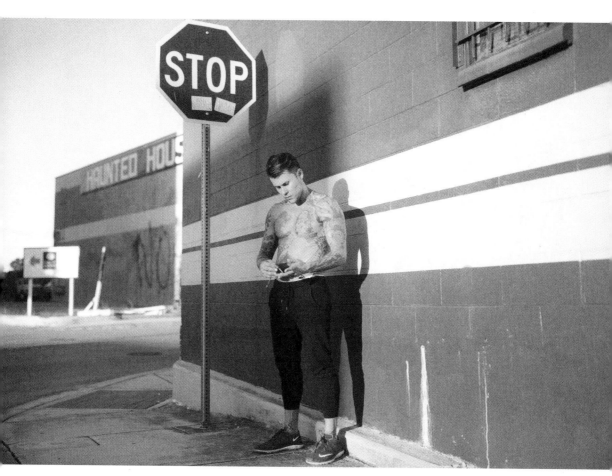

"Polyamory is a beautiful full circle of acceptance, understanding, compassion, and love. Our brand of love isn't inferior or superior to any other kind. It's just what works for us."

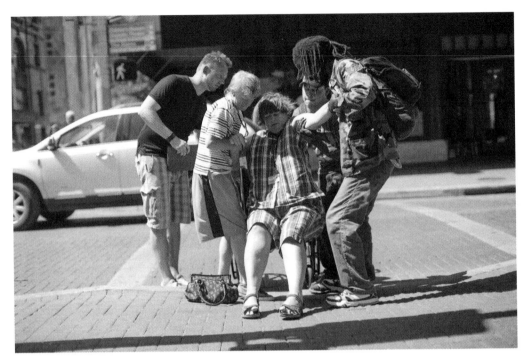

"Ma'am, we've got you."

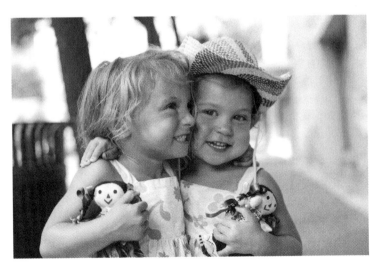

"She's my sister!"

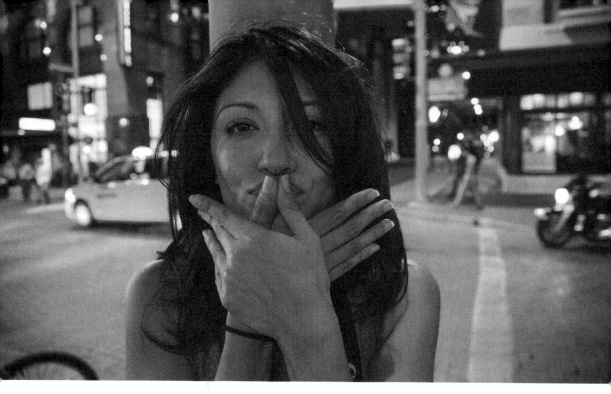

"I went from being a customer service rep for my dad in San Antonio to an assistant editor at a magazine in New York. And I could not have done it without God. If there's one story I'd tell, it's that nothing is impossible with faith."

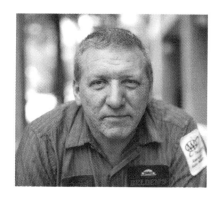

"I changed careers at forty-five, and it was the best thing I've ever done. Figure out what you love and be passionate about it. Live life happy, man. Money is *not* everything."

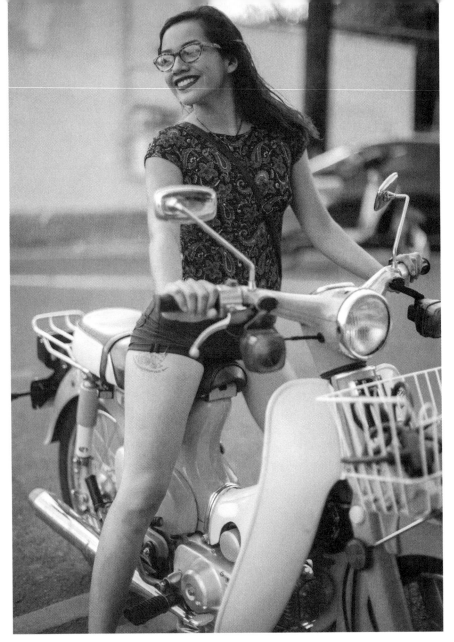

"Don't ever sell your soul. There is a passion for everyone, and this world is too beautiful."

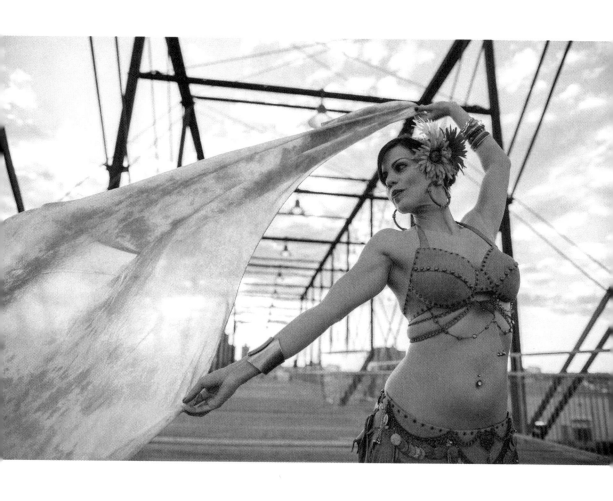

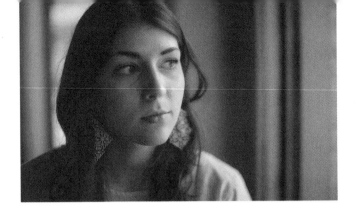

"Memories over materials."

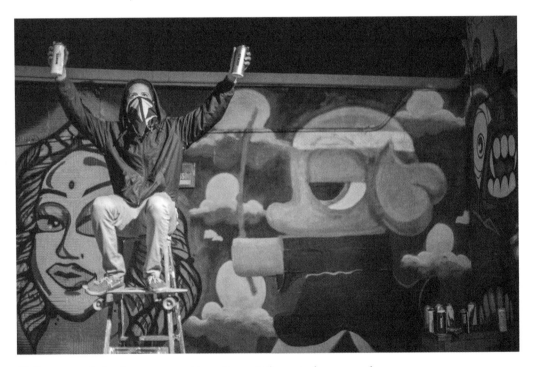

"When people look at my creations I want them to have good vibes instead of just seeing a name on a wall. I work in a lot of grimy locations, so my art will be the light in the dark."

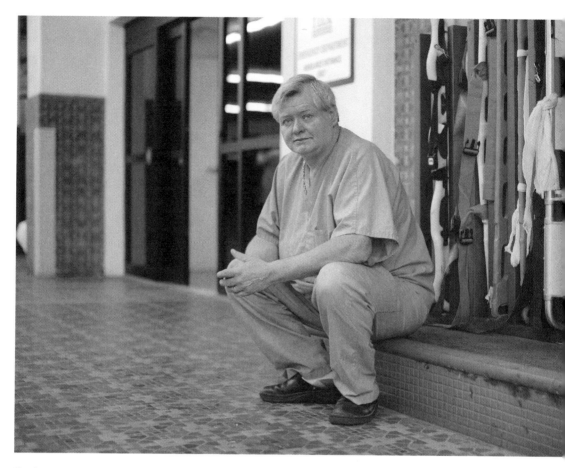

"When I was a kid I used to brag to my father about what I would do in my life. He would say, 'Don't tell me, show me.' On the day I walked across the stage and graduated from medical school, I looked over at my father and said, 'Dad, I told you I could do it.'"

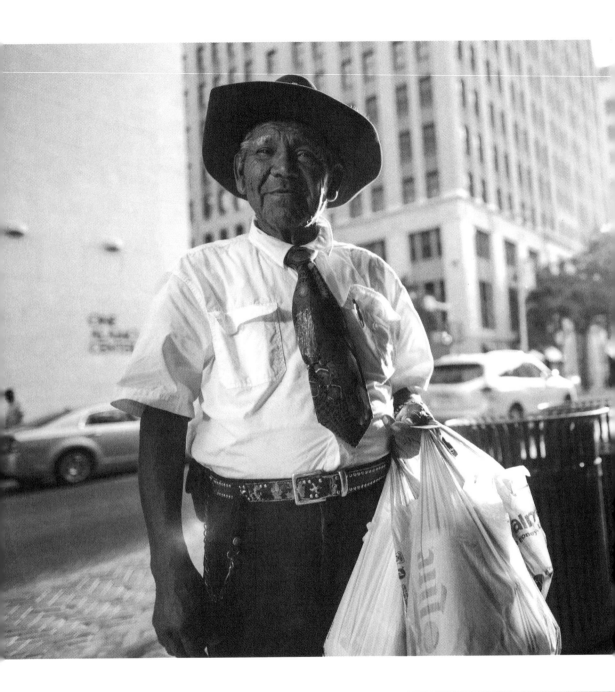

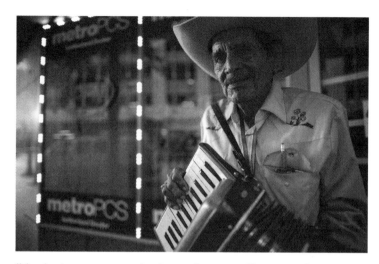

"I'm losing my eyesight, but at least I still got two [expletive] workin' ears."

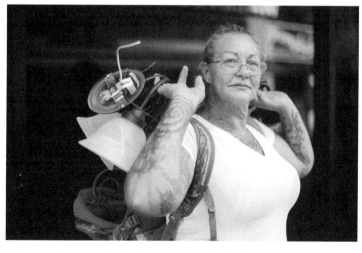

"I've made some bad choices in my life, but that doesn't make me a bad person."

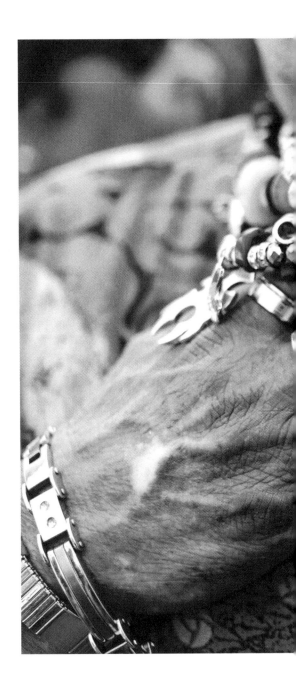

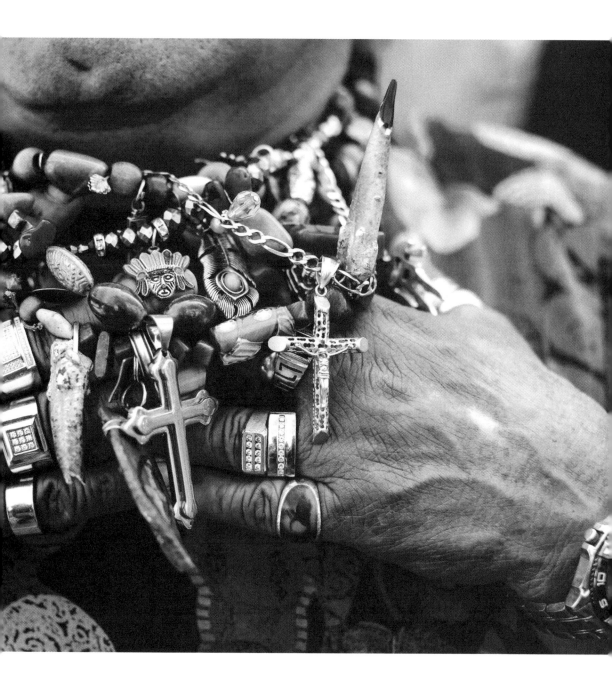

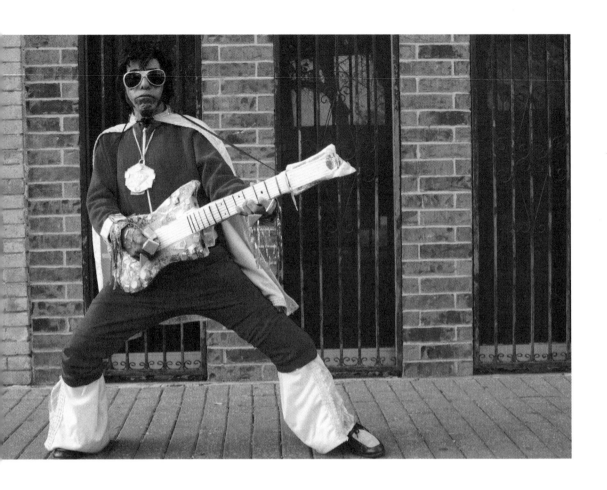

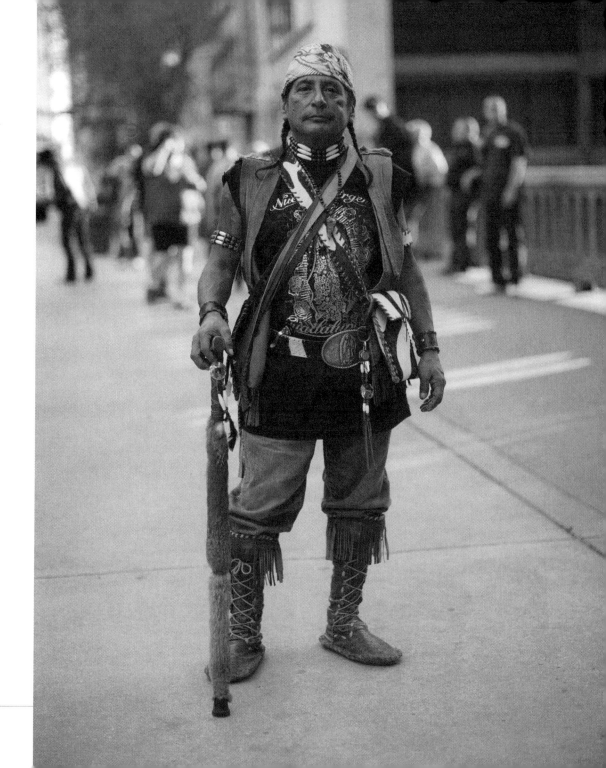

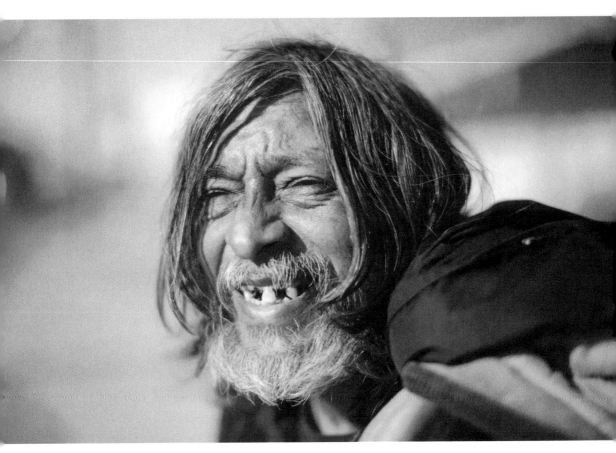

"The orange light from the sun will burn you, but the white light from your camera has illuminated the good in my world."

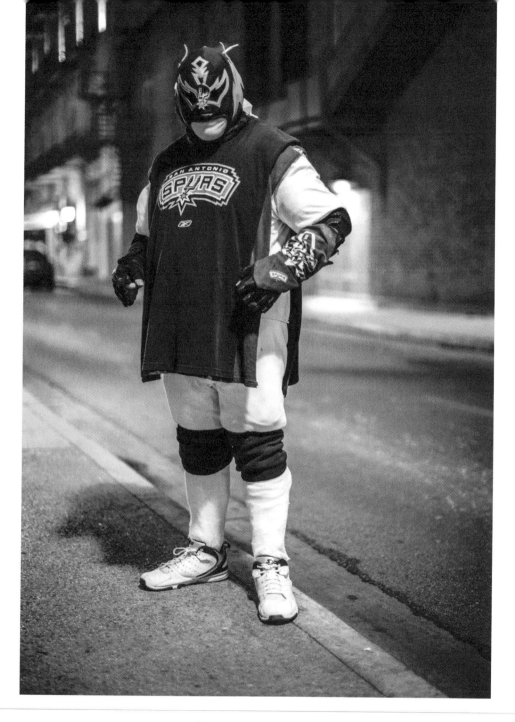

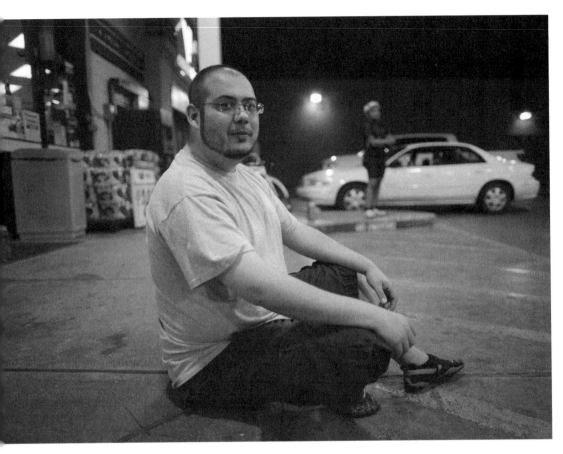

"When I unplugged myself from mass media about five years ago, I found that much of my internal dialogue had been affected by ideas perpetuated by society. Buying into society's opinions is what hindered my confidence. Confidence isn't being brave or boastful; it's a deeply held belief that you're capable and that anything is possible."

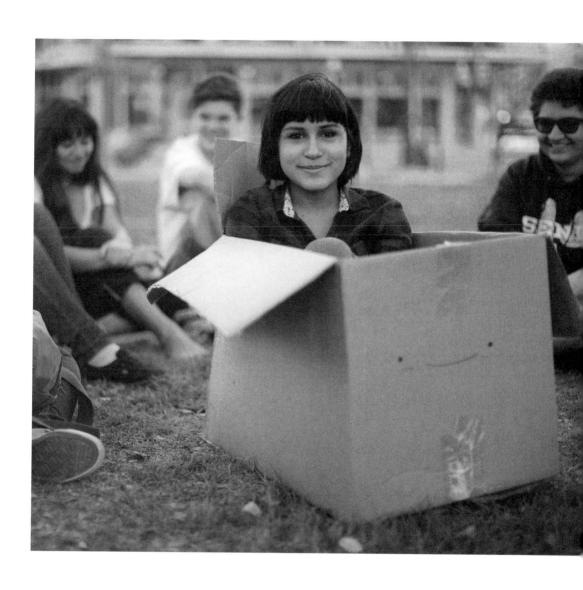

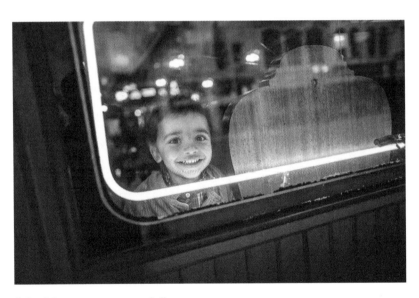

"She likes to scare people."

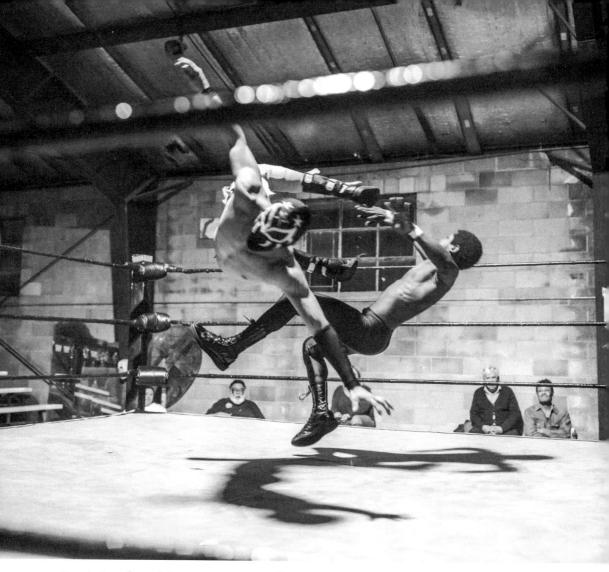

Fantástico, from Monterrey, Mexico, "knocks out" his combatant.

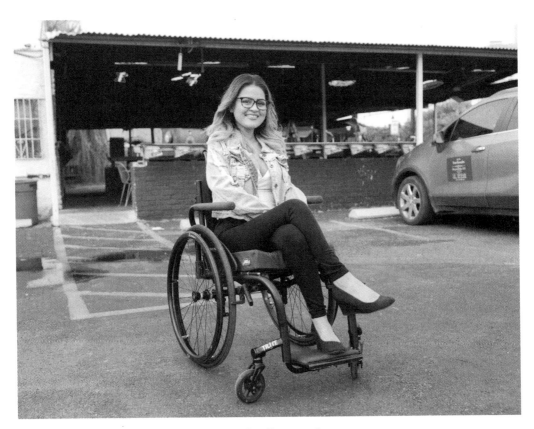

"My sister and I were at a concert. People all around us were crowd surfing. One of the security guards picked me up to help me get closer to the fun. Another great moment was when I went water skiing, even though I was strapped in so I could only see the sky. I used to be afraid to try new things because of my disability, but now I'm living life."

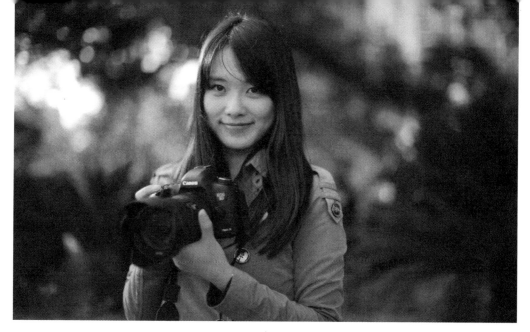

"I just moved here from China, and it's the biggest decision I've ever made. It's the first time I've left my family and friends, but it has taught me how to live alone and to deal with people from a different culture."

"I had a stroke when I was a baby and almost died. The doctors told my parents I would never walk or finish school. Today I am walking, and I'm in graduate school."

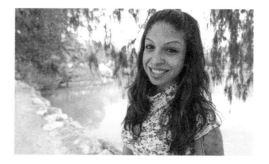

"Earlier this year I got very depressed. I know I'll get through anything because I have my dad. He always stands by me, even at my worst times, and that means the world to me."

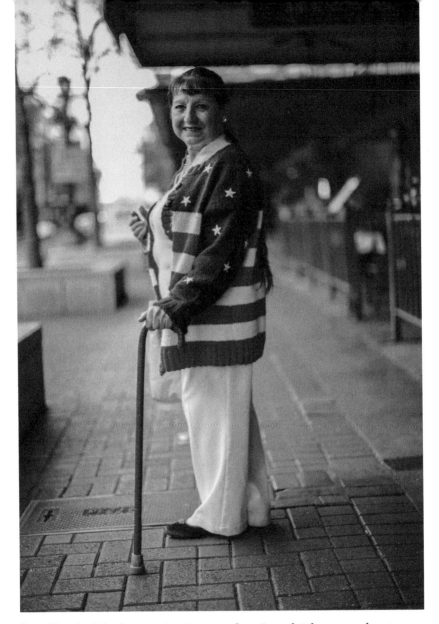

"I suffered a life-threatening injury when I got hit by a car about a year ago. This sweater I made after my recovery symbolizes my ability to overcome obstacles."

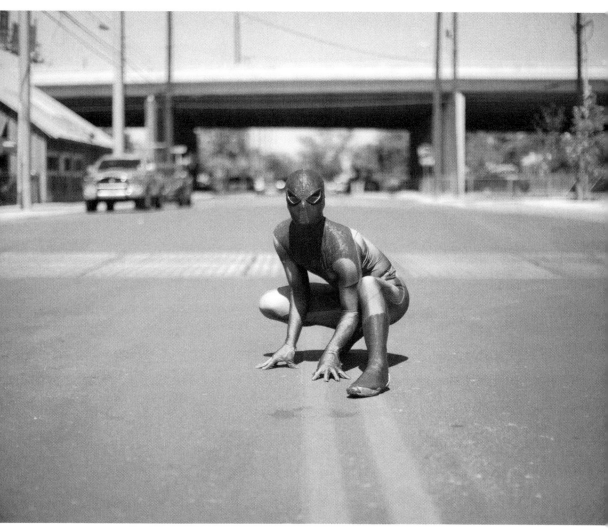

"I heard I was needed."

"She's strange."

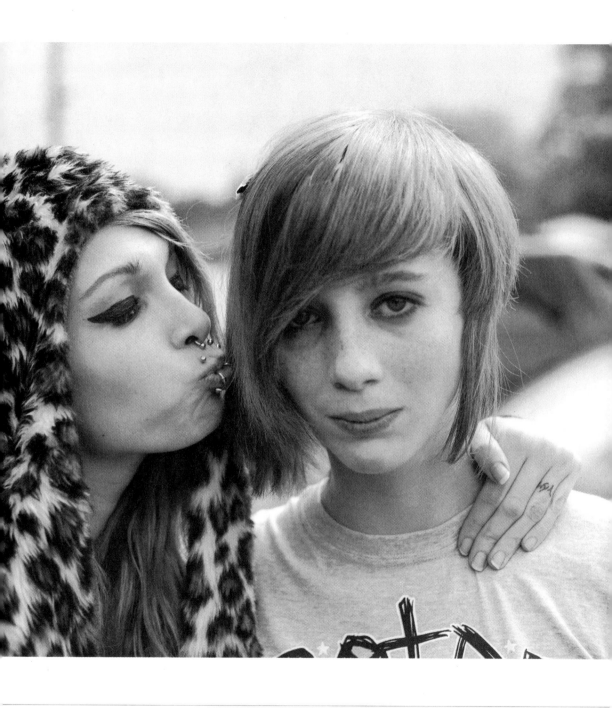

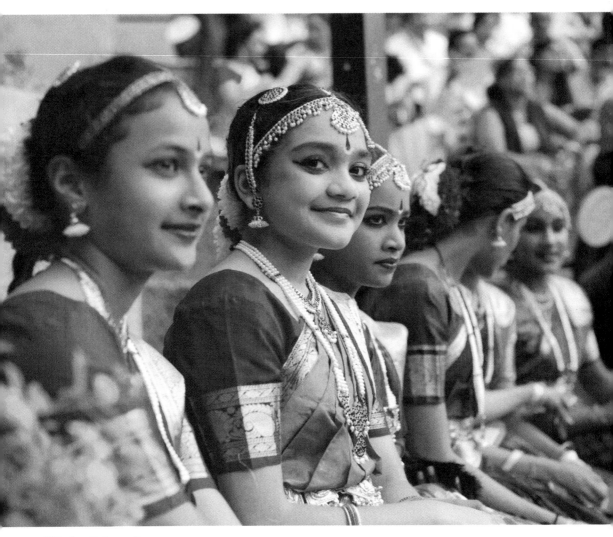

"Today I dance."

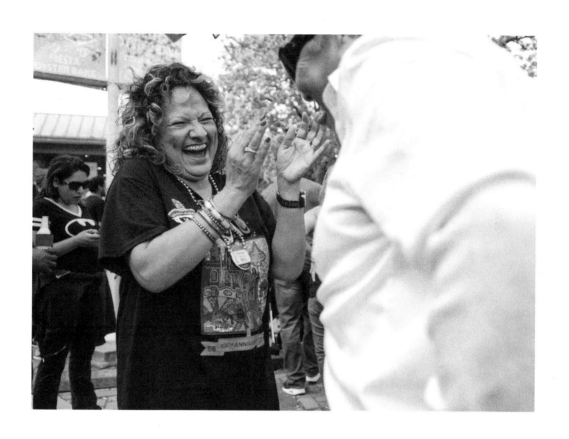

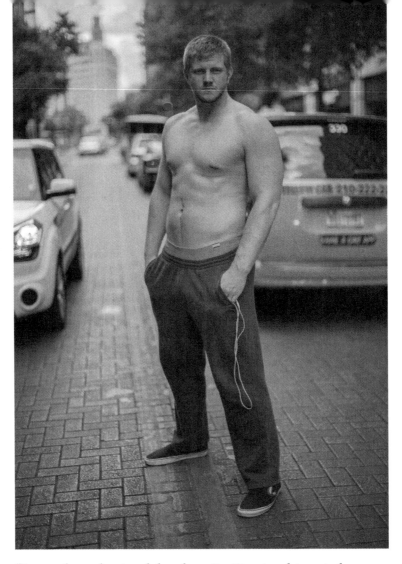

"I went through a tough breakup. Jiu-jitsu taught me to keep my emotions in line. Break your anger into the simplest components by asking yourself questions about your feelings. You'll make yourself happy—and those around you too."

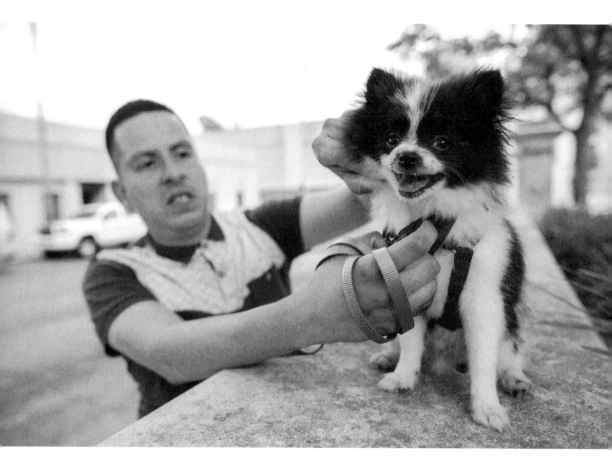

"When I was studying in D.C. I was excited to be surrounded by educated people. But I quickly realized that some weren't as bright as I thought. They couldn't believe I was Mexican because of how well I spoke English."

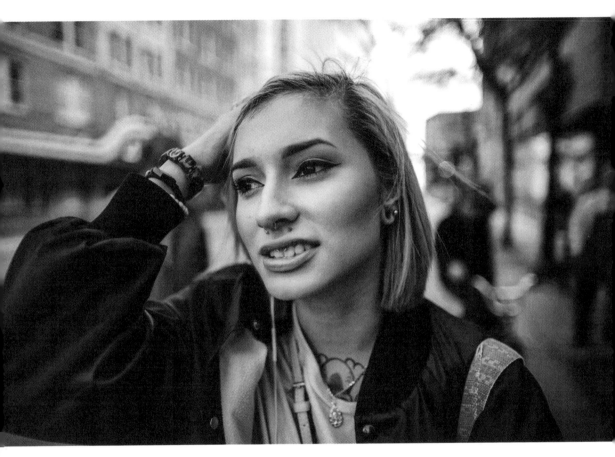

"So many of my friends in the neighborhood are getting pregnant. I feel like there isn't enough sex education in our schools. It should be taught in school and at home."

"My life in San Antonio: Work. Work. Work. Sing. Sing. Church. And then one more sing for when I'm feeling stressed out."

"I moved to San Antonio for a guy, but it didn't work out."

"I feel lost."

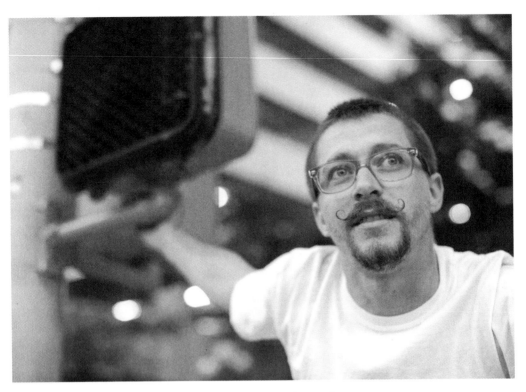

*If you saw your sixteen-year-old self walking down the street, would you stop to say anything?*

"No, I'd say nothing."

*Why?*

"Because he'll do just fine."

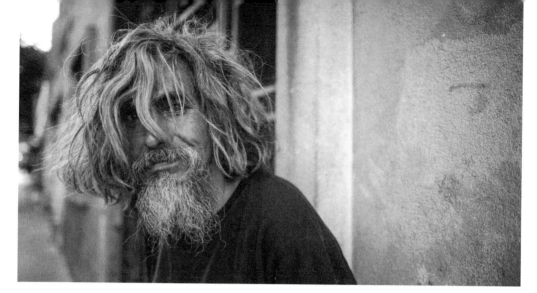

"Life is beautiful."

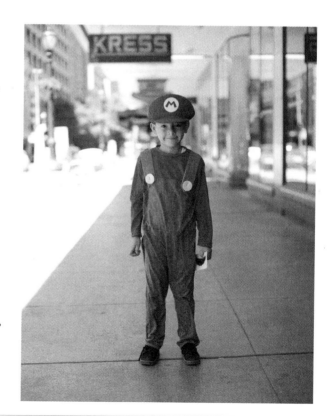

"Today is my birthday."

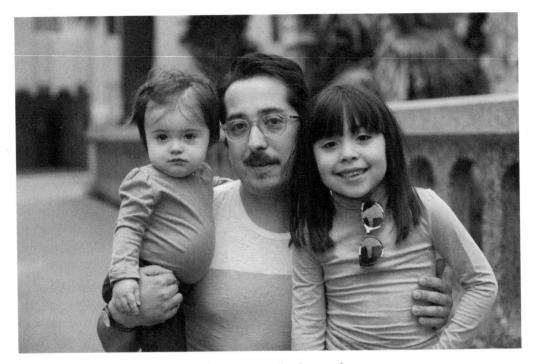

"I'm hoping that teaching my children what I've learned from traveling on my own and growing up will help them become well rounded and more knowledgeable than me."

"Yesterday my daughter asked if heaven is high in the sky and if it's possible to take a plane there. She's starting to think abstractly. One of my biggest wishes is for her to grow up able to think critically on her own."

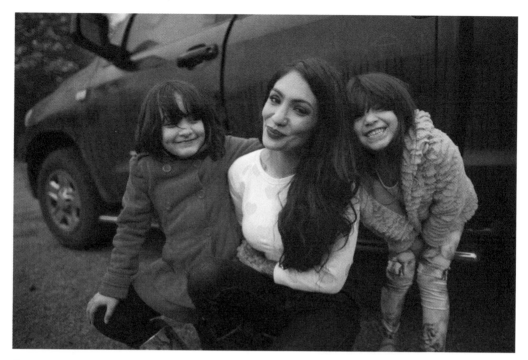

"My kids are smarter than most adults because they're not quick to judge."

"When my children speak, their voices bring me back to moments when I was a child."

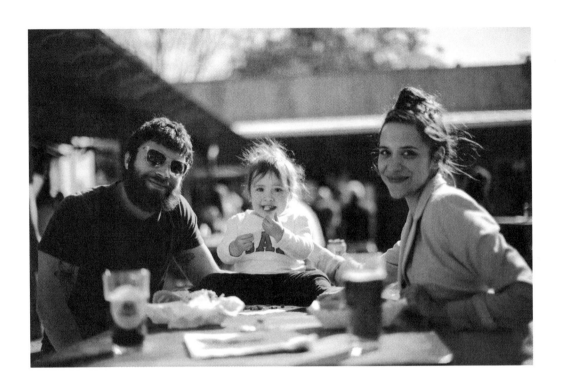

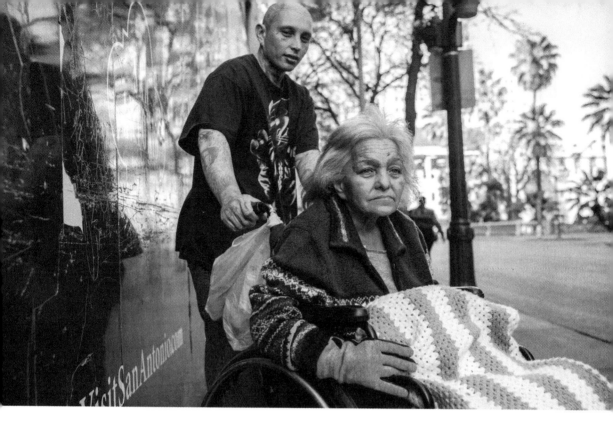

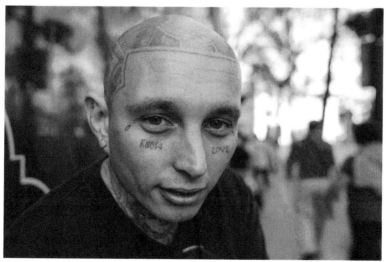

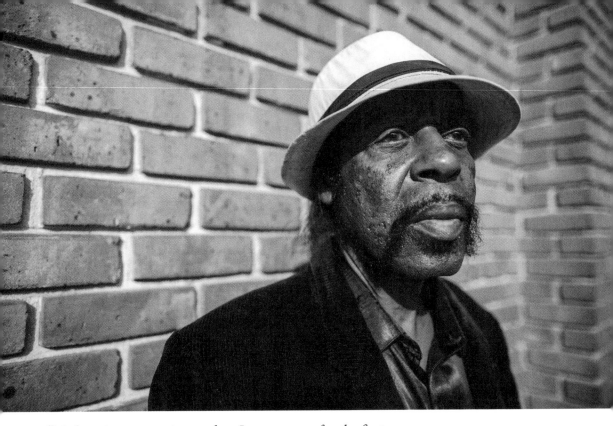

"My happiest moment was when I saw my son for the first time. I didn't get a chance to know him long because he passed away when he was three months old. It's been twenty years, and I still miss him like I did the first day."

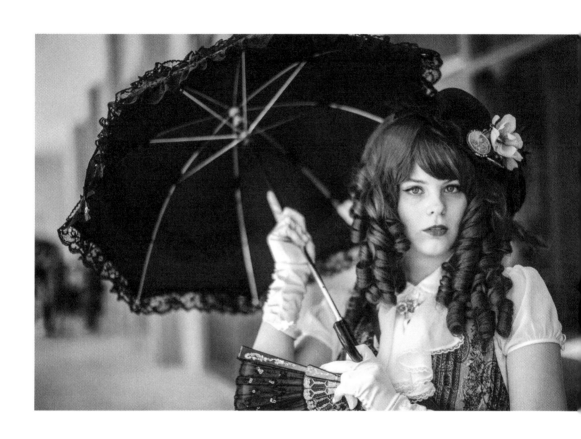

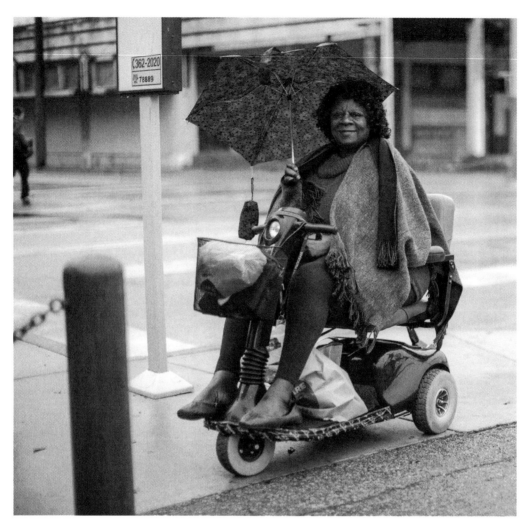

"My knees are messed up and they keep me from walking, but if you want to know something about me, let me tell you. This motor vehicle isn't going to keep me from doing what I got to do. If my path requires some off-roading, you better believe I'm coming through!"

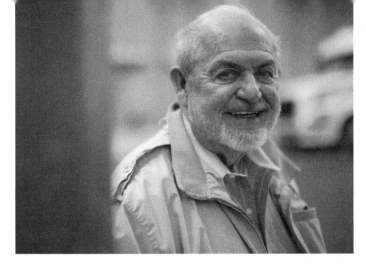

"My happiest moment is the day I met my wife."

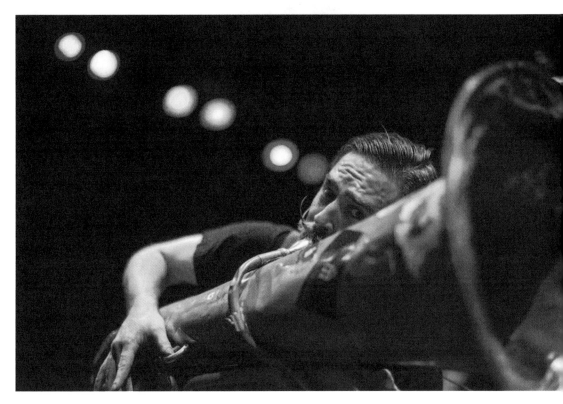

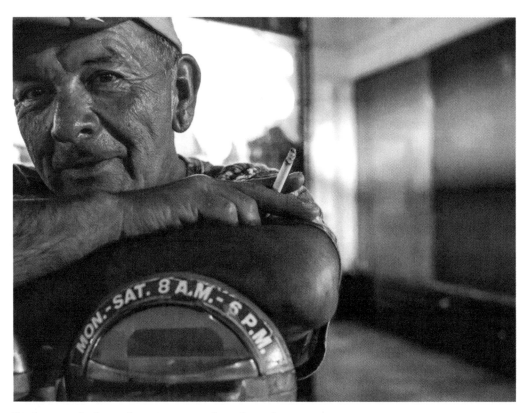

"I chose to be homeless. Everyone has their thing. I mean, look at you. You're riding around on your bicycle taking pictures of people, and I bet there are a lot of people who think that's pointless."

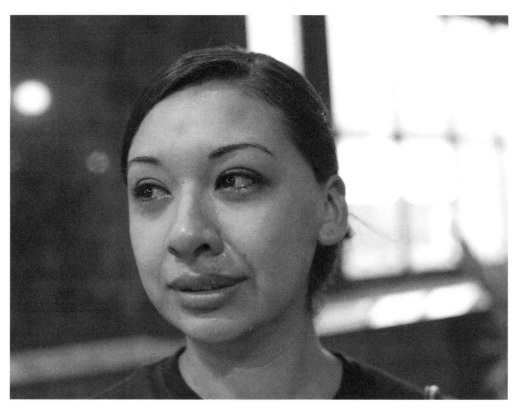

"Today was probably the worst day ever. People stole from me. I'm a food server and, you know, this is really hard on me. I have two kids, and I'm all that they have."

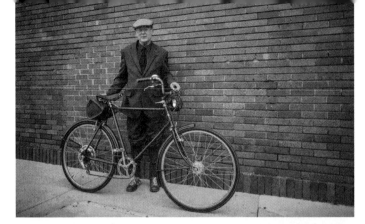

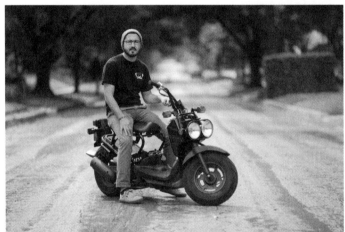

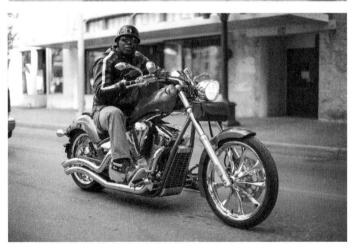

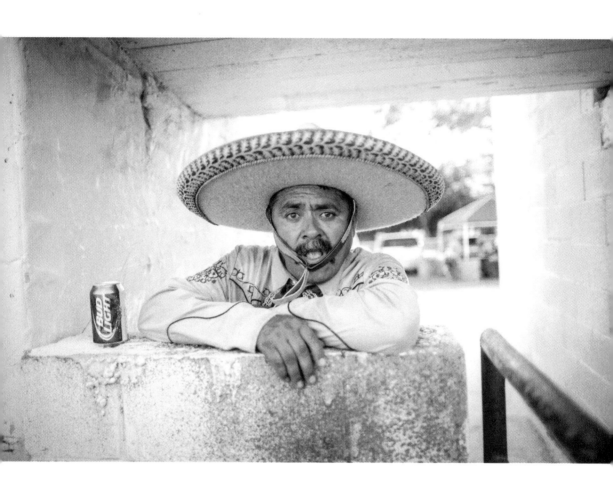

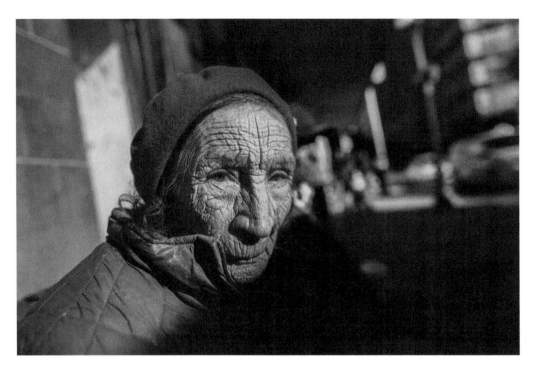

"My son lived most of his adult life in a wheelchair. One morning I went into his room and called his name. He didn't respond. He had passed on to God. He was my only child."

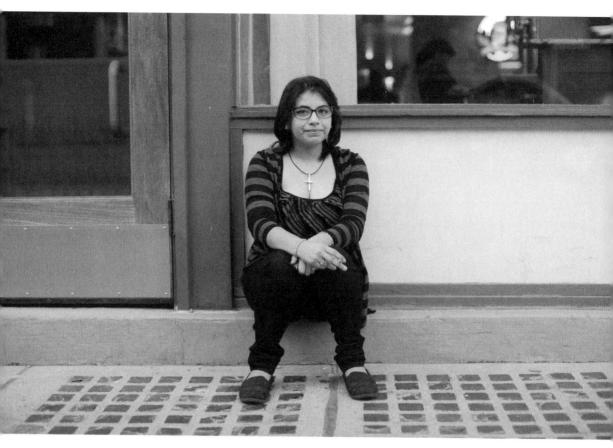

"When I was three, my mother had to give my brother up
for adoption. We tried looking for him recently, but we can't
find him. His name has changed. Our mother had to make a
really hard decision, and she chose him for adoption because
she thought he was the strongest. She couldn't afford all of
us, and she wanted us to have a better life."

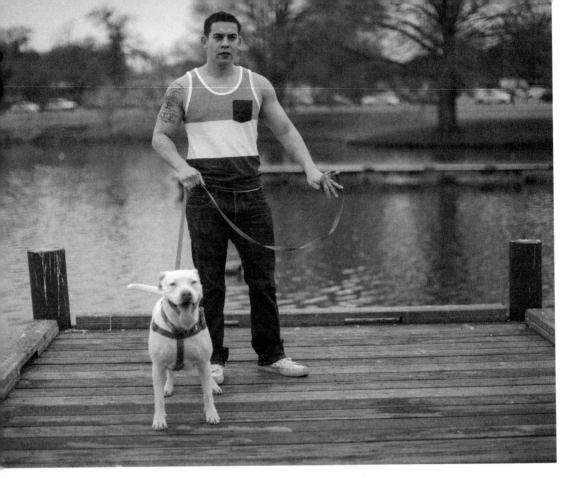

"I was stationed in Japan for two years. It was nice to be exposed to another culture. I learned structure but also how to have tolerance. Sometimes things aren't going to be how you want them, so it's best to be chill."

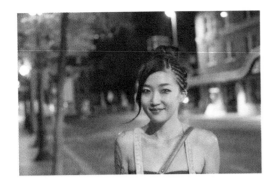

"Be happy. Time heals all things."

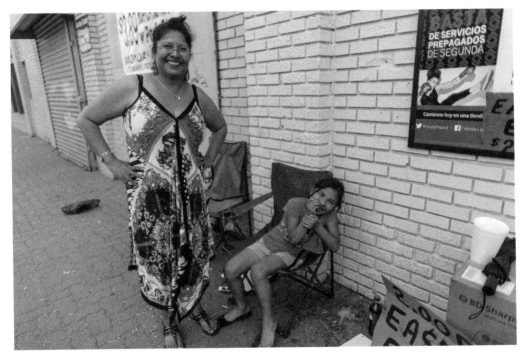

"I want her to know you can forgive one time, two times, three times, but if the person she chooses to love continues to make the same mistake she needs to know when enough is enough."

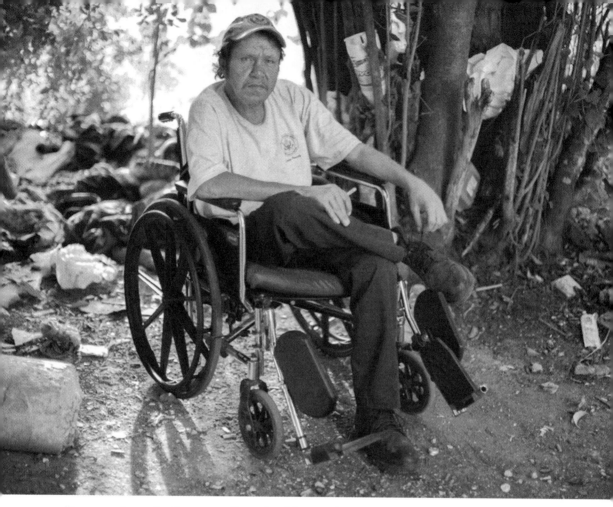

"I was on leave in Germany. Some buddies and I were having drinks, and we got in trouble with the cops. I was supposed to catch a flight the next morning, but I didn't get out in time. I found out later that the plane crashed and many people died. I called my mother as soon as I could, and when she answered she was hysterical. I learned that day the amount of love my mother had for me."

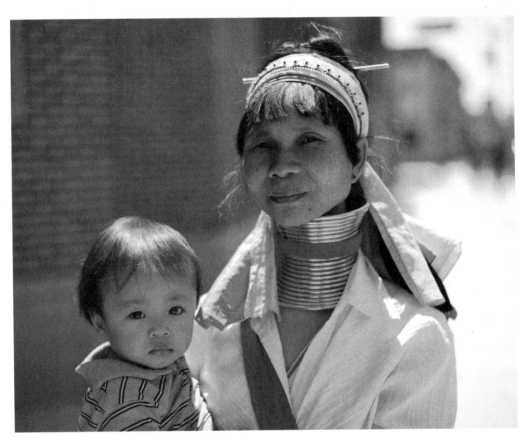

*Sabai dee mai krap? [How are you?]*

"Sabai sabai." [Happy happy.]

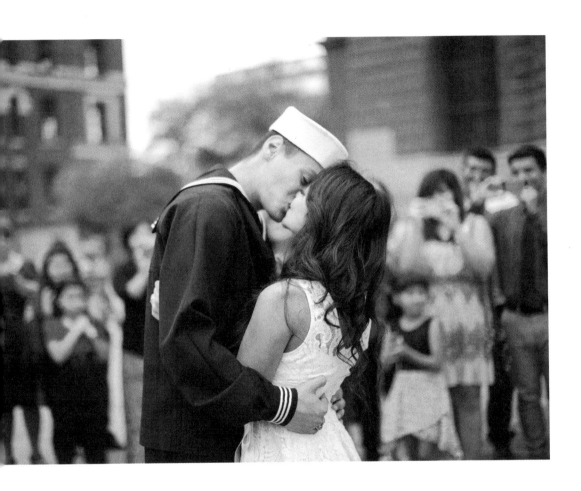

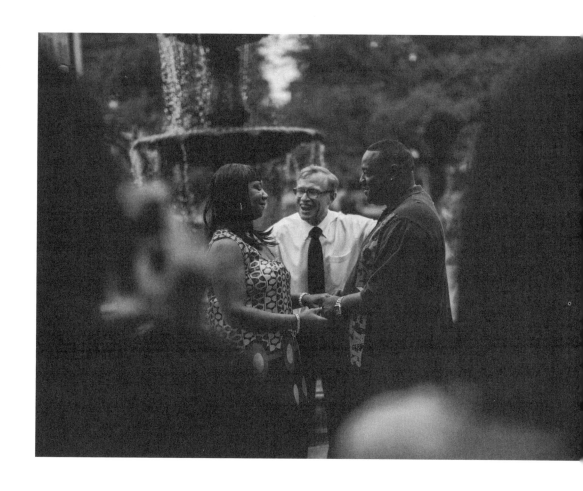

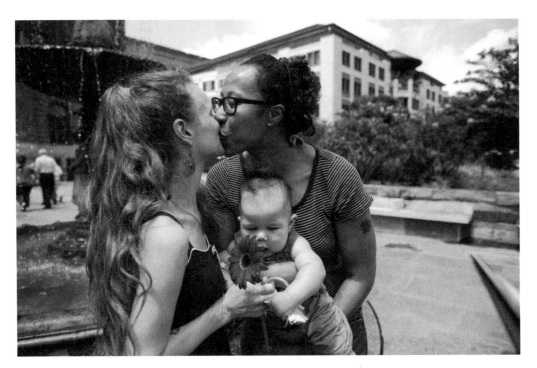

"I'm just in disbelief. I didn't think we would be able to get married in Texas."

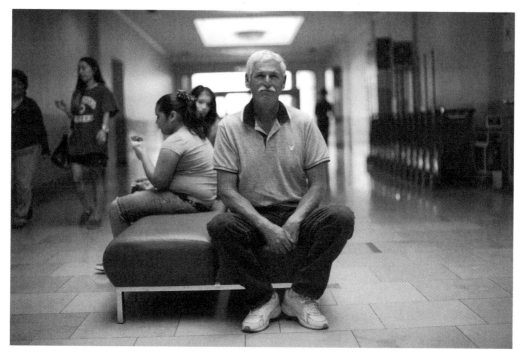

"I have a lovely wife. We've been married for twenty-eight years. We're best friends, and I think that's why we've stayed together for such a long time."

*What's the secret to a long and happy marriage?*

"Do what she tells you."

*Anything else?*

"No, that's about it."

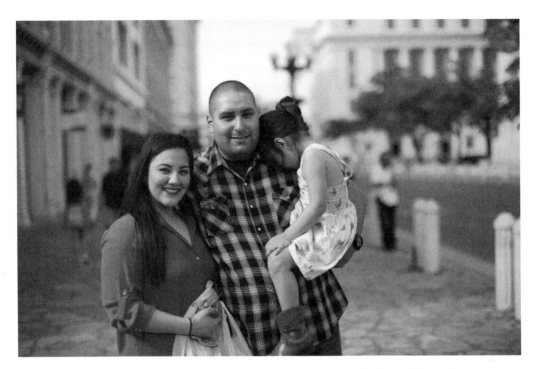

"We met in high school. He would steal my seat in class, and I hated that. One afternoon after dance rehearsal he saw me sitting on the curb and offered to keep me company while I waited for my parents. It was adorable when he offered to share his raspa with me."

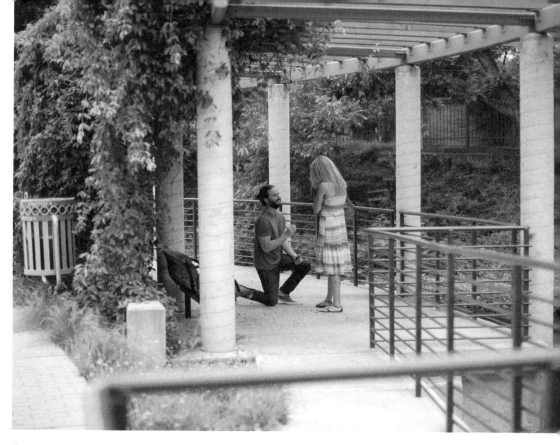

"Will you love me forever?"

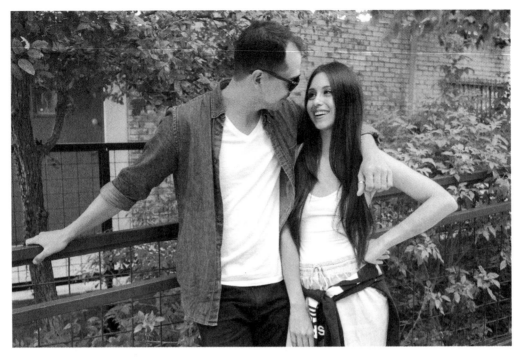

"She left me once because I stopped caring. It was what I needed in order to start appreciating what I had. To be in a good relationship, you have to continue to always be conscious of your girl. You've got to show her how much she means to you every day, and that's the bottom line."

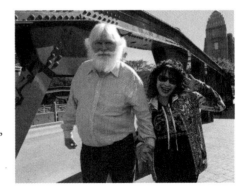

"Look, I married Santa Claus!"

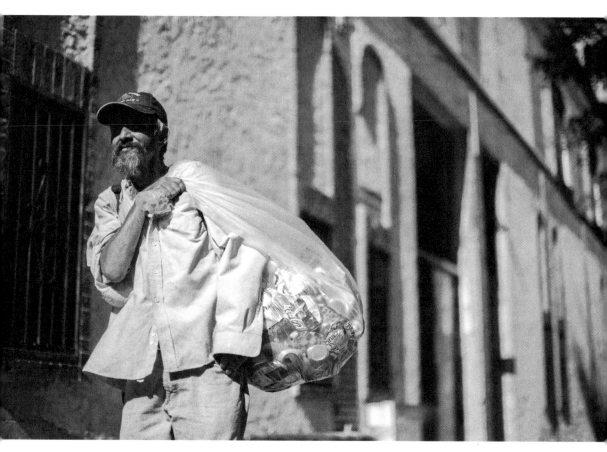

"My only wish is for the value of recyclable cans to go up."

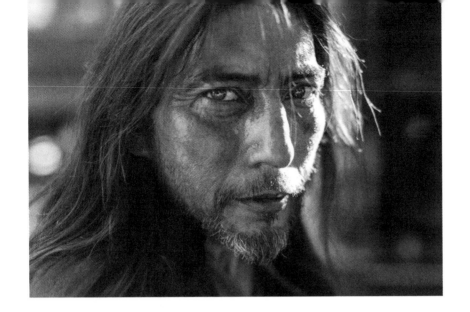

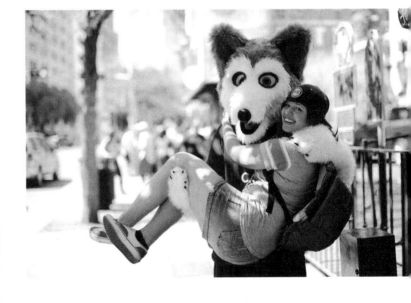

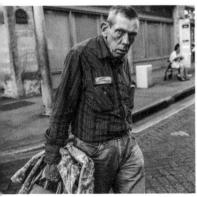

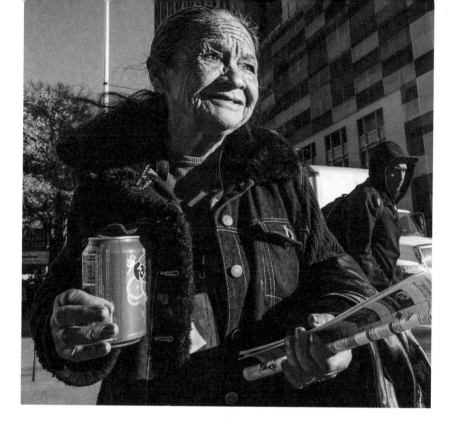

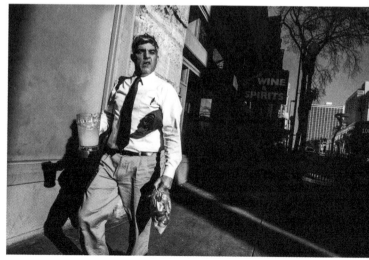

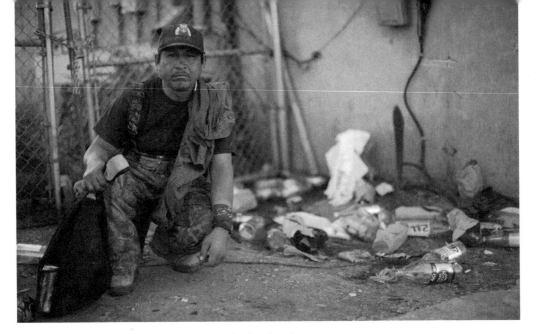

"One night I decided to sleep under the bridge because it was raining hard. Someone attacked me and stole my valuables. It was an error on my part to sleep there, but I was thinking, What kind of human being steals from a homeless man?"

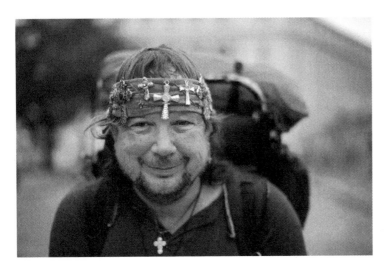

"When you believe in love and faith, you need nothing else."

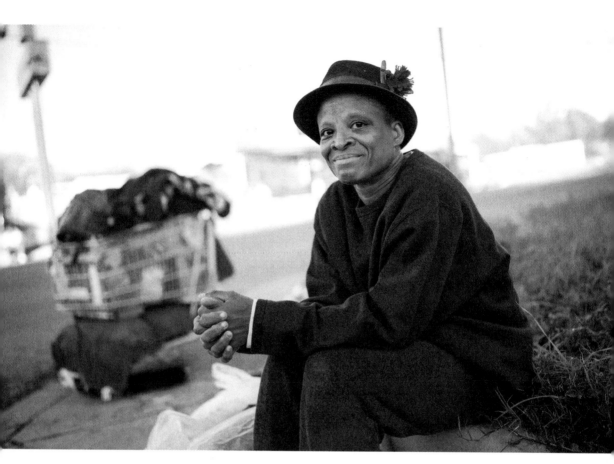

*What is beautiful about homelessness?*

"There's me."

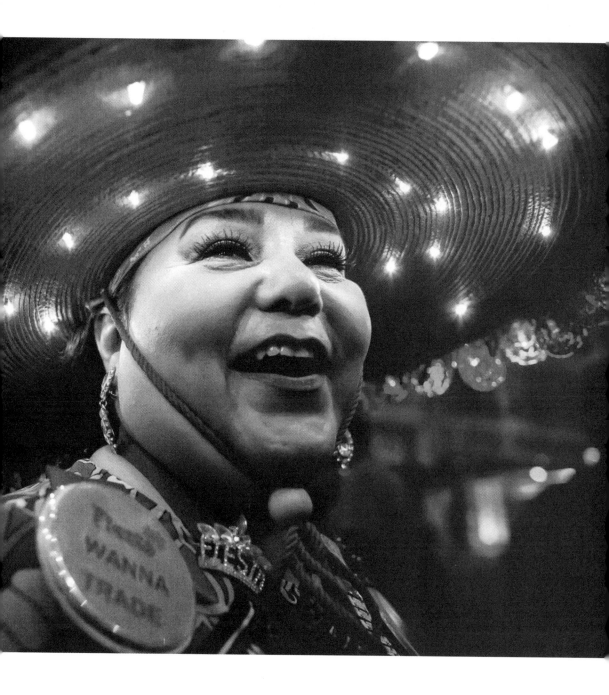

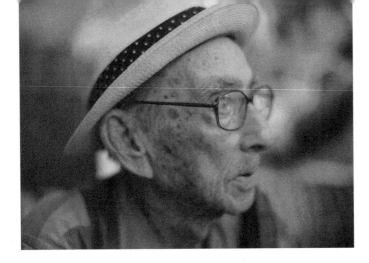

"Don't be afraid to invest in your city. I've been living in San Antonio since 1922."

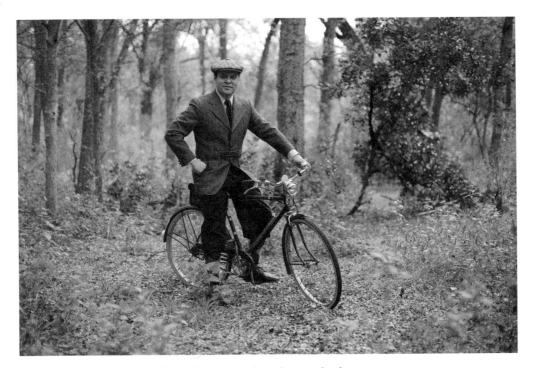

"I wish city leaders would really hear, rather than politely listen to, the public's input on the city's development."

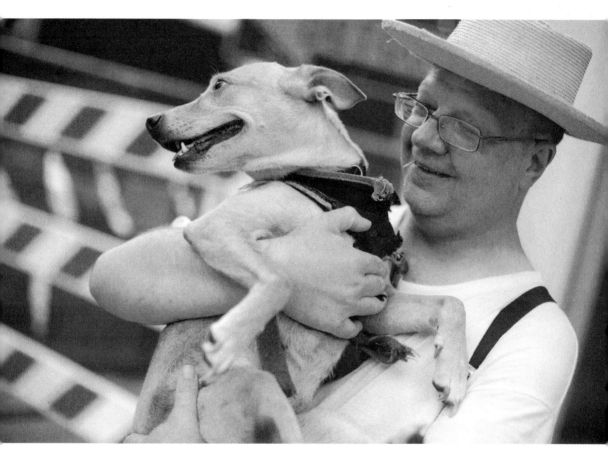

"San Antonio is one of the best places I've ever lived. The people are super friendly, and that isn't going to change."

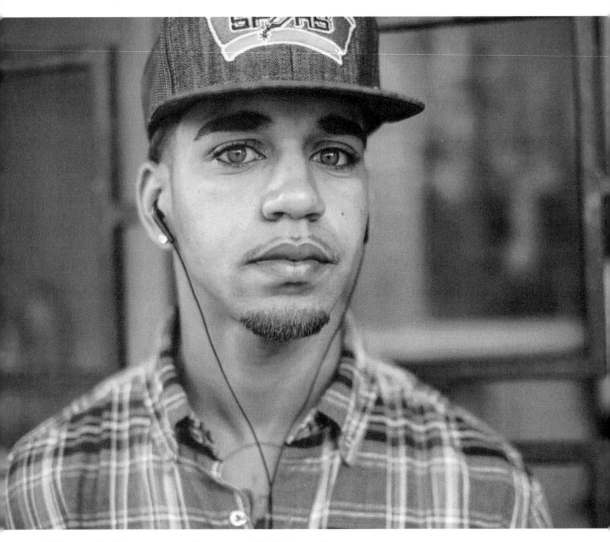

"I'm tired of San Antonio being so old-fashioned, man. Where are the music studios downtown? Where are the trains and bicycle lanes, the late-night coffeeshops? Whatever happened to those hip-hop music performers who used to jam out in front of the Alamo?"

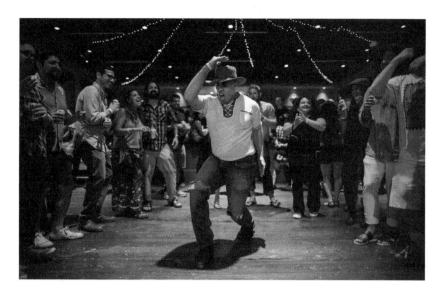

"I never turn down a dance-off."

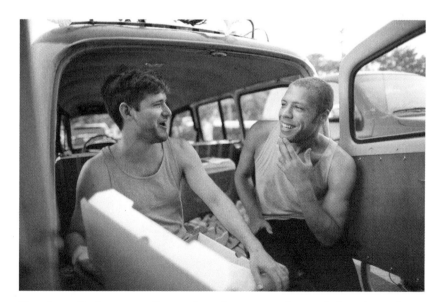

"It takes a little more effort to live downtown, but it definitely makes for a cool lifestyle."

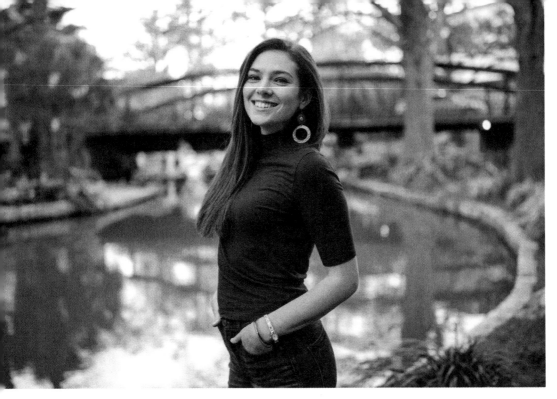

"There are more young people moving downtown because it's rich in cultural diversity, music, and art."

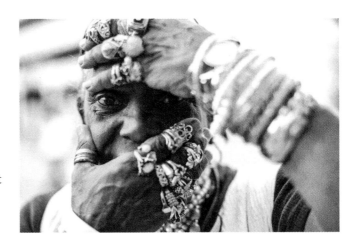

"I'd love to see more street art downtown."

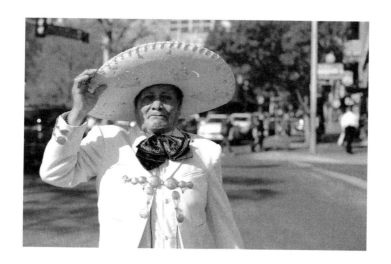

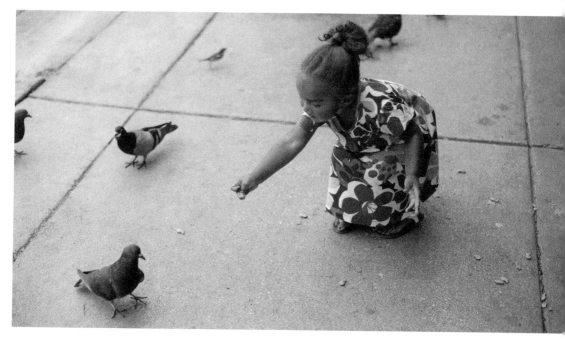

"Here."

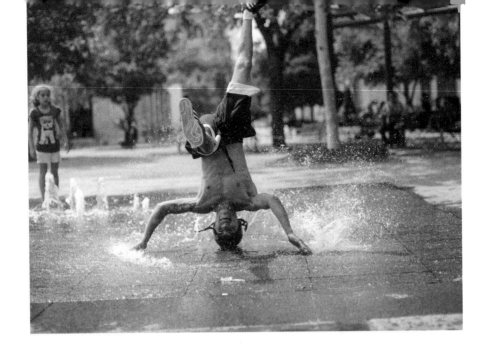

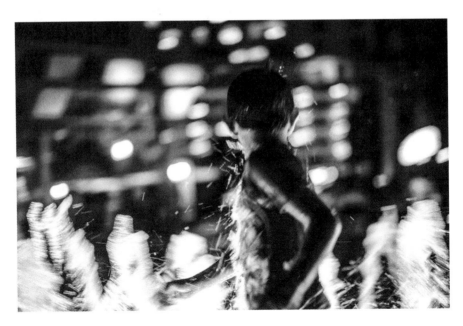

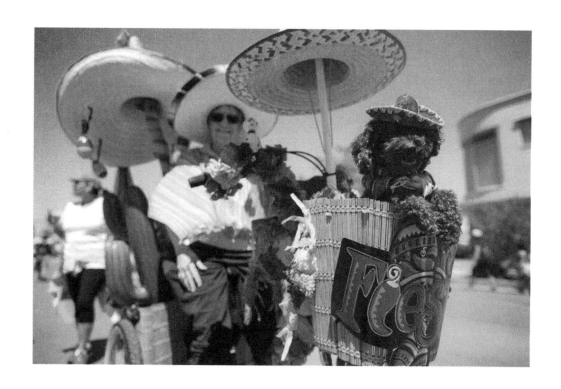

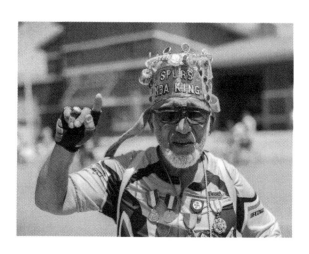

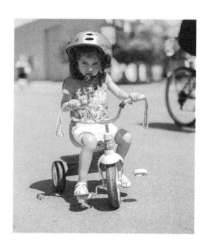

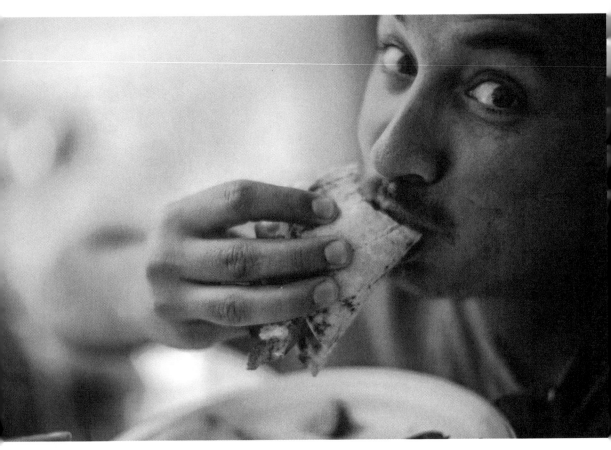

"San Antonio is known around the world for having some of the best tacos, and this is one of them."

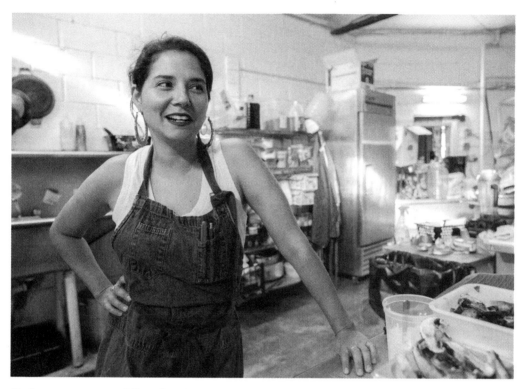

"When I was in middle school my mother signed me up for swimming lessons. I really liked swimming so I asked her if I could go to the high school with the best swim team. She did whatever she could to move us into that school district. There was this impression that since I came from the inner city I didn't know how to swim. I cried, but I practiced hard, and when I tried out for the high school team I performed so well they had to put me on varsity! Don't ever let someone make you believe you can't do something."

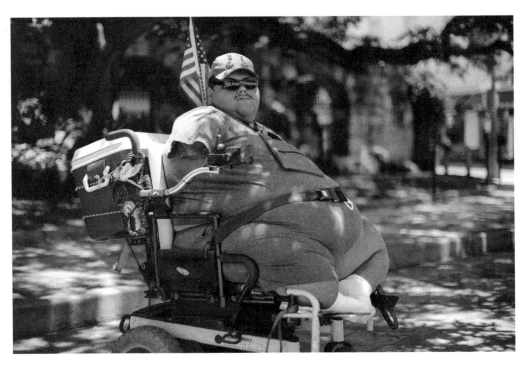

"The toughest obstacle I had to overcome was learning how to take care of myself emotionally."

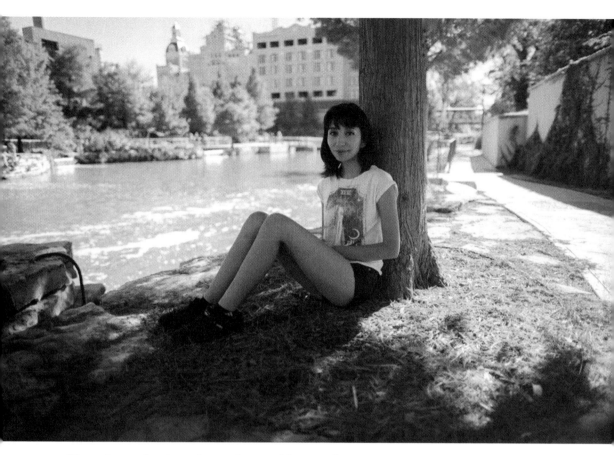

"I was in an abusive relationship, and having the courage to leave made me realize how much I took for granted. I should have been showing the people who really love me my appreciation instead of giving my heart to someone who didn't appreciate my love."

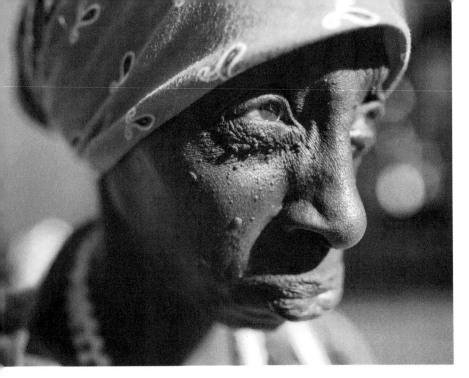

"One of my defining experiences was during Hurricane Katrina. My friend and I were in the living room when the water started rushing in. It got to our knees within minutes. We're thankful to be alive."

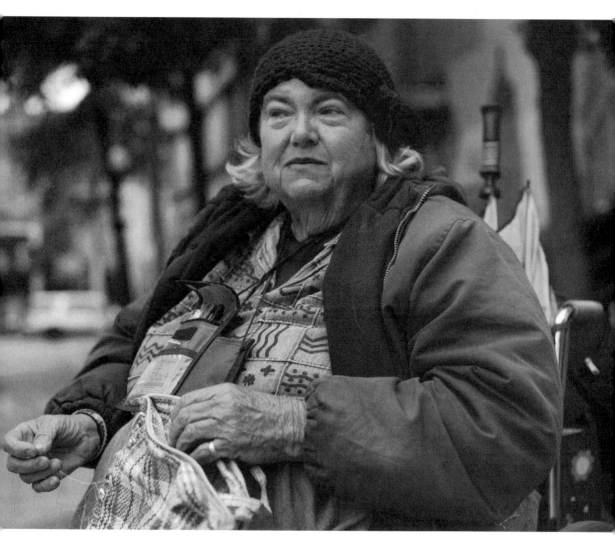

"I taught for thirty-four years. I taught George Strait in the ninth grade. He was a smart little kid, but music was his thing, of course. I miss teaching."

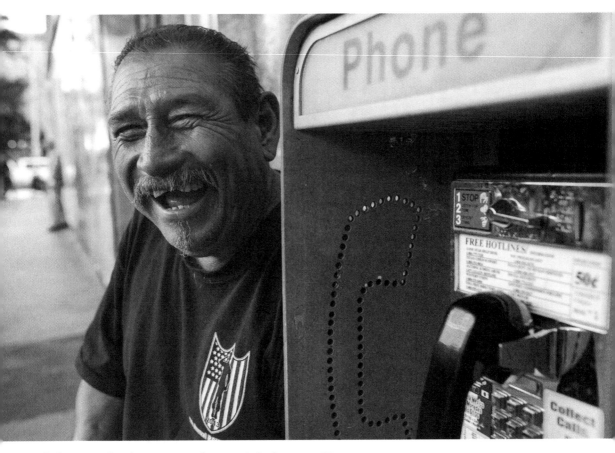

"There used to be a movie theater right here on Houston Street. I had my first date there. I was fifteen years old, and the girl I took out was eighteen. Man, I got so high I ended up spending all of my money that night. Hell, I think she took advantage of me."

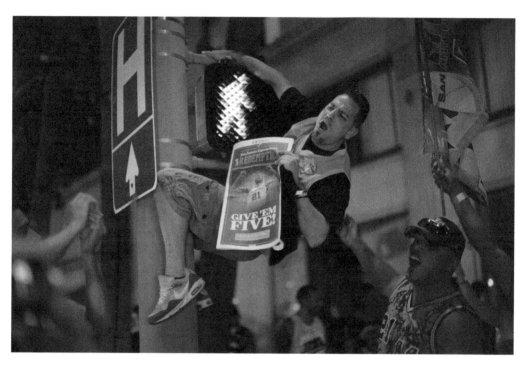

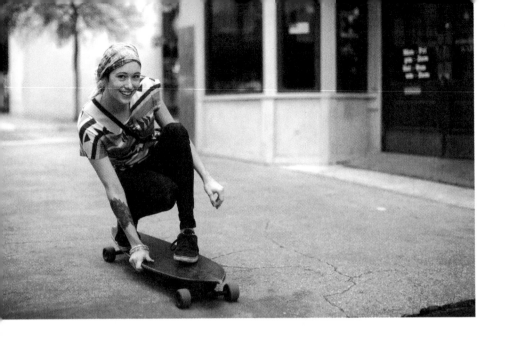

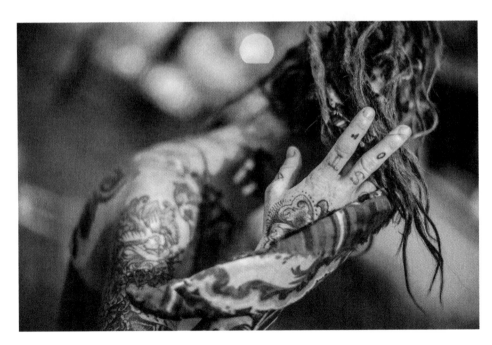

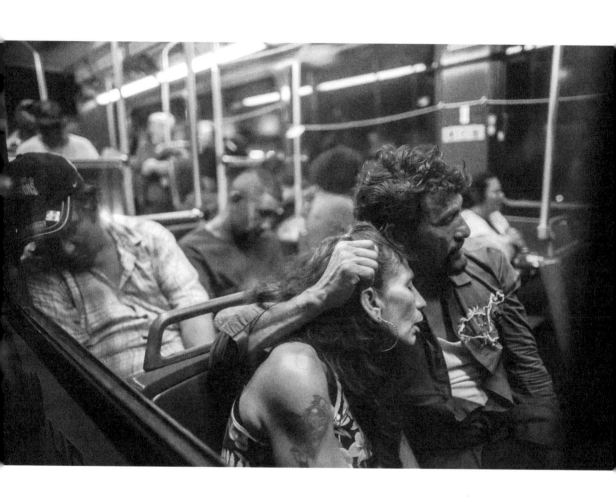

# Acknowledgments

I would like to express my gratitude to the many people who saw me through this project. To all of those who provided support, talked things over, read, wrote, and offered comments and advice. To photographer and dear friend Scott Ball, who joined me on this project. To Trinity University Press, especially Steffanie Mortis, Sarah Nawrocki, and Tom Payton. To Anne Richmond Boston for the great design. To the people I met on the streets, and to the ones who have become great friends. To the people who have inspired me, my mentors and colleagues. It's been a wonderful journey.

Grandmother, Gloria Brown
Grandfather, Anthony
  "Popi" Brown
Mother, Sharry Page
Father, Michael Cirlos
Stepmother, Irma Cirlos
Valerie Mercury
Stella Savage
Scott Stephen Ball
Marcella Garcia
Edward Aaron Romero
Javier Flores
Christina Marie Garza
Jaime Rene Gonzalez

Michele Jacob
Alison Christine Reynolds
Julie Ledet
Joe Harjo
Lisa Krantz
Rick Loomis
Samantha Martinez
John Medina
Laurence Seiterle
Claudia Loya
Stephanie Guerra
Janis April Edralin
Livingston Brandon Burnett
Brett Winning

Ian Smith
Patrick Galvin
Dave Watts
Benjamin Blakelock
Blake Closner
James William Kollman
Sheila May Nacionales
Kameron Lund
Kiran Kaur Bains
Jeff Vaillancourt
Pat Digiovanni
Alicia Digiovanni
Liz Burt
Amanda Poplawsky

Published by Maverick Books, an imprint of Trinity University Press
San Antonio, Texas 78212
tupress.org

Book design by Anne Richmond Boston
Author photograph by Josh Huskin
Photographs on pages 16, 62, and 80 bottom by Scott Ball

ISBN 978-1-59534-793-0 paperback
ISBN 978-1-59534-794-7 ebook

The photographer discussed the Humans of San Antonio project with the people who appear in the photographs, including planned publication of the images in various media. Neither the publisher nor the photographer asserts any editorial point of view or portrayal aside from the intent of conveying and celebrating the city's rich cultural and social diversity from an educational and public interest standpoint. Inquiries about the photographs within the book should be directed to the publisher.

Trinity University Press strives to produce its books using methods and materials in an environmentally sensitive manner. We favor working with manufacturers that practice sustainable management of all natural resources, produce paper using recycled stock, and manage forests with the best possible practices for people, biodiversity, and sustainability. The press is a member of the Green Press Initiative, a nonprofit program dedicated to supporting publishers in their efforts to reduce their impacts on endangered forests, climate change, and forest-dependent communities.

The paper used in this publication meets the minimum requirements of the American National Standard for Information Sciences—Permanence of Paper for Printed Library Materials, ANSI 39.48–1992.

CIP data on file at the Library of Congress
22  21  20  19  18  |  5  4  3  2  1

**MICHAEL CIRLOS** founded Humans of San Antonio, a photojournalism project inspired by Humans of New York, to celebrate the visual story of downtown San Antonio. He holds a degree from the University of Texas at San Antonio, and he is the recipient of the Awesome SA Community Award. He is the photographer for Centro San Antonio and works with the San Antonio Department of Arts and Culture and other downtown organizations. Follow Cirlos on instagram.com/humansofsa.